THE ART OF
BENIN

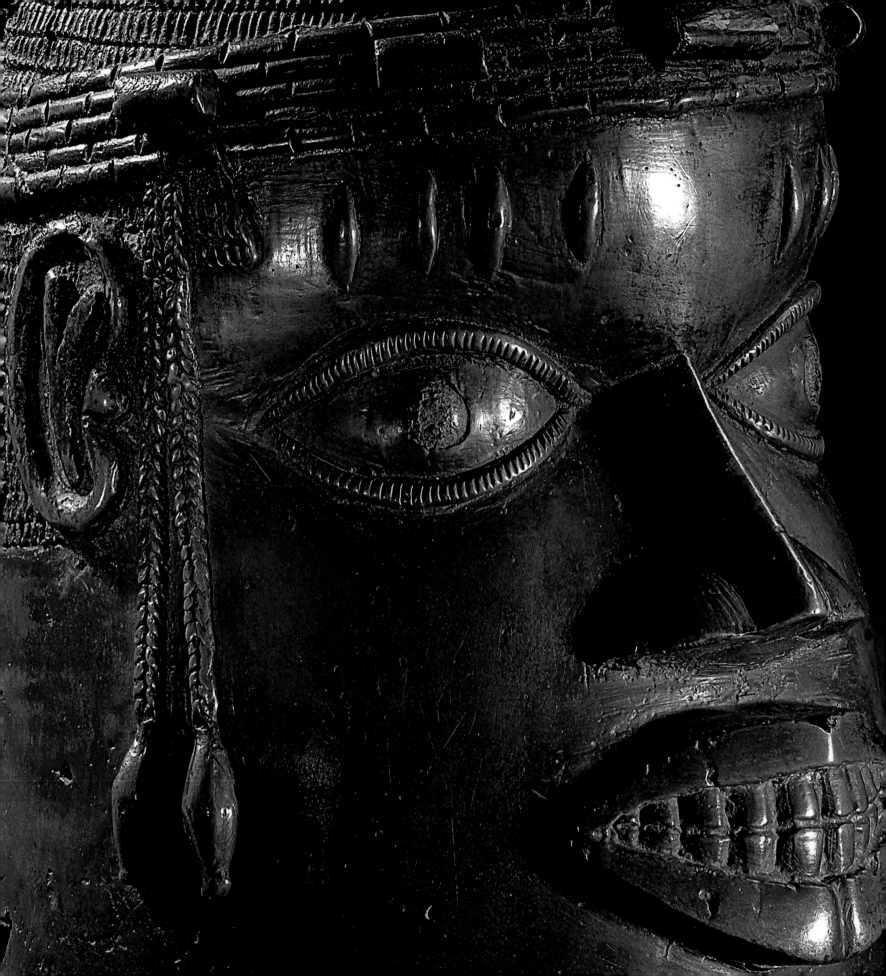

THE ART OF
BENIN

NIGEL BARLEY WITH PHOTOGRAPHS BY
KEVIN LOVELOCK AND MICHAEL ROW

THE BRITISH MUSEUM PRESS

THIS 'CHARACTER' of the Ododua
masquerade (see p. 66) is Uwen, wife of Ora
and a deity responsible for rainfall, sunshine
and fertility. *Ododua mask. Brass, 18th century.
H. 33.4 cm, W. 19.6 cm, D. 27.2 cm* frontispiece

THIS AFRO-PORTUGUESE salt cellar is
in three sections, offering two chambers for
condiments, supported by horsemen and a
smaller figure with a gun. The strange nude
figure at the back is the local artist's attempt
to make sense of an image of a Western
angel, his wings having become a leafy motif
on the topmost vessel. The lid is a European
replacement. *Salt cellar. Ivory, 16th century.
H. 21.4 cm* right; detail page 6

THIS FIGURE shows a bearded hunter,
slain antelope around his shoulders, with
bow, horn, quiver and dog. Although found
in Benin in 1897, it is clearly in a quite
different style, with the bulging eyes and
concave toenails characteristic of some
Lower Niger Bronze Industries works.
*Figure of a hunter. Cast bronze, ?17th century.
H. 37.3 cm, W. 22.4 cm, D. 17.6 cm*
page 9; detail page 8

© 2010 The Trustees of the British Museum

Nigel Barley has asserted the right to be identified
as the author of this work

First published in 2010 by The British Museum Press
A division of The British Museum Company Ltd
38 Russell Square, London WC1B 3QQ

www.britishmuseum.org

A catalogue record for this book is available from
the British Library

ISBN 978-0-7141-2591-6

Printed in China by C&C Offset Printing Co. Ltd

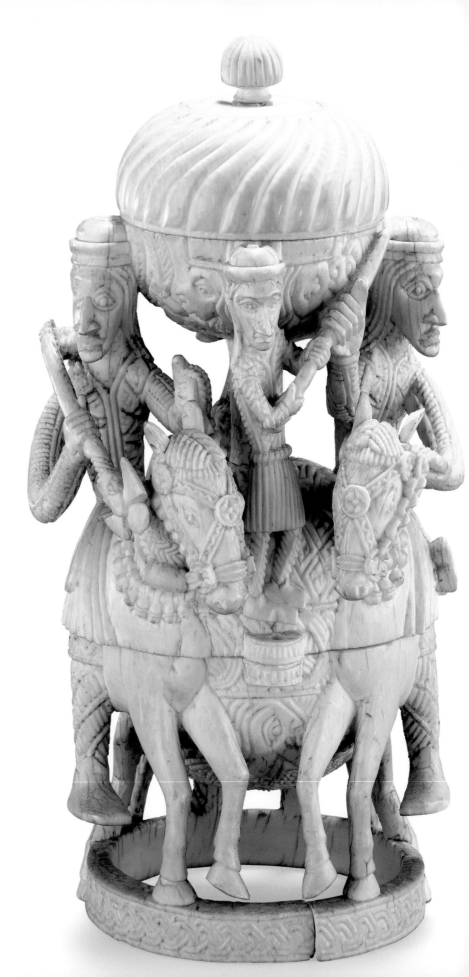

CONTENTS

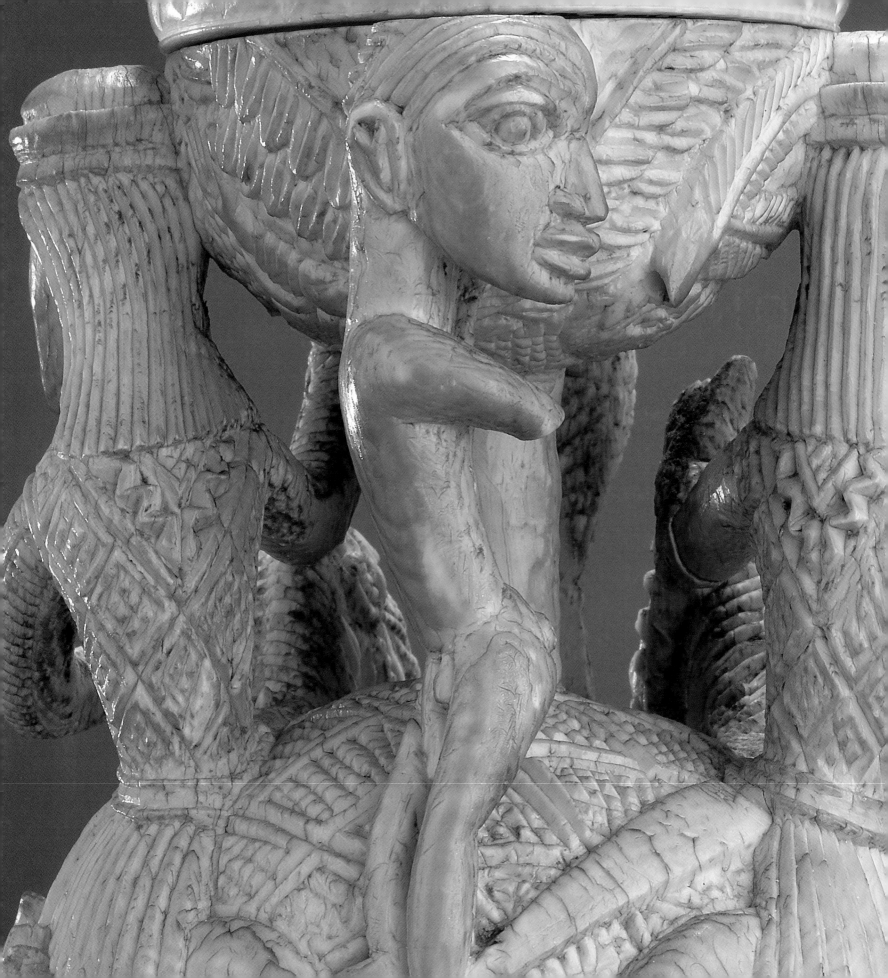

DIRECTOR'S FOREWORD

THE BENIN COLLECTION OF THE BRITISH MUSEUM IS ONE OF THE WORLD'S MOST PROMINENT, though considerably smaller than that, for example, in Berlin. Benin objects fall into two apparently distinct groups. First, there are the palace ivories and cast metal works ('Bronzes'), made by court artists as marks of royal distinction. Then there are the exquisite carved ivories, made as souvenirs for foreigners who were among the first Europeans to visit West Africa. While the latter have been in the West since the sixteenth century, the former were almost unknown when they were dramatically revealed at the end of the nineteenth century and both the general public and professional 'experts' on Africa struggled to incorporate them into the world as then known.

Benin metal castings have always been inherently political, initially expressive of local royal hegemony and dominance over the outside world and subsequently drawn into the colonial conflicts that marked the brief period of British power in southern Nigeria at the very end of the imperial period. While the Benin Bronzes in the Museum have as varied and colourful an acquisition history as any others – bequests, gifts, purchases, etc., featuring many eminent names among their former owners – all ultimately go back to a swift punitive expedition mounted by British forces in 1897, following the massacre of a diplomatic mission to that kingdom in the same year. Although not one of the major military operations of the time, it had a high profile, being seen as a vindication of national honour. In many ways, it was the Falklands Expedition of its day, with emotional farewells to the ships, a rapid and decisive outcome and reception of victorious forces at Windsor by the Queen, to whom objects from Benin were presented. This book traces some of the ways in which the objects from the Benin court were initially used to bolster a colonial view of Africa but went on to help to completely transform it. They have always been part of a changing dialogue about Africa's place in art, in history, and in the world more generally.

The British Museum can lay claim to a special place in the development of Benin scholarship. For at least a century, successive generations of curators, beginning with the pioneering Sir C.H. Read and O.M. Dalton, established an unbroken line of academic research that was continued by scholars such as William Fagg and John Picton, who brought new methods and insights to bear. In the course of this, Benin studies moved back and forth between history, art history and the growing subject of anthropology, and grew to a prominence that has set them among the foremost art objects of the world.

Neil MacGregor
DIRECTOR

PREFACE

MUSEUMS ARE OFTEN SEEN LIKE TIME MACHINES, TAKING US BACK TO AGES AND PLACES THAT have disappeared, where the objects on display 'come from', and allowing us to witness, in some relatively simple way, events that happened long ago and far away. However, objects in museums, though physically preserved and stable, are far from immutable. They move constantly between different frames of reference. In periodic shifts of perception, they may be abruptly incorporated into larger wholes where new interconnections are established as old concerns fall away. They are subject to constant reinterpretation as our basic ideas about the world, human creativity and mankind are revised in the light of contemporary experience, and we see them in new ways which challenge the received orthodoxies of the past. New technologies may reveal unsuspected information that previous scholars could never have guessed at, bringing new certainties or eroding our faith in old beliefs. Individual objects may rise and fall in our estimation for reasons as vague but powerful as changes of fashion or the ill-defined and adaptive notion of what constitutes aesthetic beauty.

This book aims to show that the royal objects from Benin in the British Museum illustrate all the vagaries to which such deliberately solid and enduring works are subject. Since they became more widely known over a century ago, they have played a vital role in the challenging and revision of the West's most basic ideas about Africa. And, in a dialogue without finality, they continue to engage our unexamined assumptions about that continent and the West and, by implication, the role of museums in intercultural understanding.

Manuscripts may be solitary productions but books never are. Sincerest thanks are due to Julie Hudson and David Noden of the Department of Africa, Oceania and the Americas for their endless patience and unstinting helpfulness in the midst of many other demands on their time, and to Kevin Lovelock and Michael Row for the excellence of their photographs. Felicity Maunder, as editor, was both stern midwife and kindly godmother.

Nigel Barley

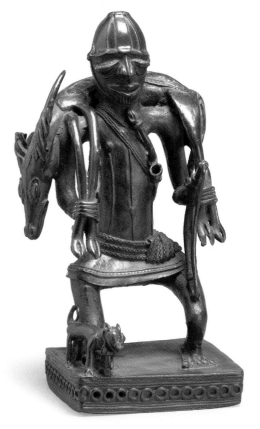

BENIN IN HISTORY

SINCE AT LEAST THE THIRTEENTH CENTURY, BENIN HAS BEEN A POWERFUL KINGDOM IN WHAT is now Nigeria. (It is not to be confused with the neighbouring modern Republic of Benin, formerly Dahomey.) While its actual borders were fluid, and expanded and shrank according to the vicissitudes of its imperial history, it was always centred on the Edo-speaking peoples on the left bank of the River Niger (Fig. 2). Edo is the name that they use for the place and themselves. Yet, at the end of the nineteenth century, the world was astonished by the revelation of its unsuspected yet sophisticated artistic tradition, from what was by then literally a backwater among the swamps and creeks of the Niger Delta. The skill, richness and antiquity of objects from Benin created a sensation in the artistic and cultural circles of the West. But what was this ancient kingdom? Where had these powerful images come from? What did they signify? And how were they best to be understood? Since that first impact, researchers have struggled to

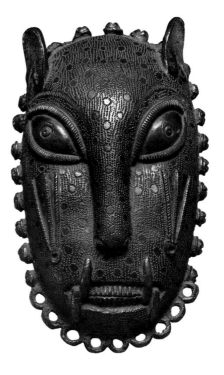

FIGURE 1 This elegant hip mask depicts a leopard, the animal represented most often in Benin art. The face of the beast is elongated and flattened to fit the usual shape of these masks. At the top is a row of solid bells while around the chin are hoops to which other bells would once have been attached. The slanting, glaring eyes and vertical whiskers give a powerful illusion of depth. The surface is marked with the alternating dots and circles that conventionally represent leopard skin in Benin. On the plaques, hip masks of this form particularly denote warriors.
Hip mask in the form of a leopard. Cast brass, 18th century. H. 17.3 cm, W. 10.2 cm, D. 5.4 cm

answer these questions. While Africa was the other continent most visited by Europeans from the fifteenth century onwards, it remained the longest unknown and it would be several centuries after those first direct contacts before Westerners even understood that the great river on the borders of Benin was the same that they had encountered a thousand miles to the north as the River Niger. The exploration of the great land mass of Africa posed far greater challenges to European travellers than even the longest of the great sea voyages that laid bare the Asian and American mainlands and the remote and unsuspected islands of the far Pacific. One view of the Age of Discovery is that myth was replaced by scientific knowledge of the outside world, yet the history of contact with Benin suggests powerfully that the two more often go hand in hand. Exploration was less a matter of finding out what was there than of fixing on the map what it was already felt must exist. After all, the Portuguese explorers who first described the city of Benin in the fifteenth century were driven by the urgent quest for the realm of Prester John, a legendary non-European Christian ruler, which was known to lie somewhere in 'the Indies', a term which at that time could include Africa. In an Iberia still threatened by Muslim incursion, its location was a major political and strategic goal. Repeatedly, they would 'discover' it in China, India, and then in Benin, before it became fixed on distant Abyssinia. Myth continued to envelop and shape the interpretation of Benin through the nineteenth century in the Europeans who saw the kingdom as the very embodiment of the 'heart of darkness', and extends nowadays to the contemporary use of its artefacts as proud national symbols on banknotes and in touring exhibitions. In the age of satellite navigation, we continue to orient ourselves by mythical maps.

BENIN AS SEEN BY EUROPEANS

It is very important not to write of Benin, as historians sometimes do, entirely in the past tense. Although its long history, documented both in the chronicles of outsiders and in its own antiquities, is what has attracted the attention of scholars, Benin – refigured as Edo State in the Republic of Nigeria – is very much a going concern. It still has its *oba* (king), its palaces, its court, its ancestral altars and its artists. It still organizes an annual cycle of complex rituals that now attract crowds from all over the world and strengthen and protect a ruler who is not simply powerful and respected but whose person, in some sense, embodies the good or bad fortune of the whole Edo people. What is known as Benin royal art – the brass castings, the ornaments of coral and ivory, the costumes and regalia – all centres around the court and the sacred person of the oba, and performs functions that are far more than merely aesthetic.

Yet Benin's place in history is complex and important. From the beginning of the fourteenth century, there evolved a travellers' literature on Africa that consisted

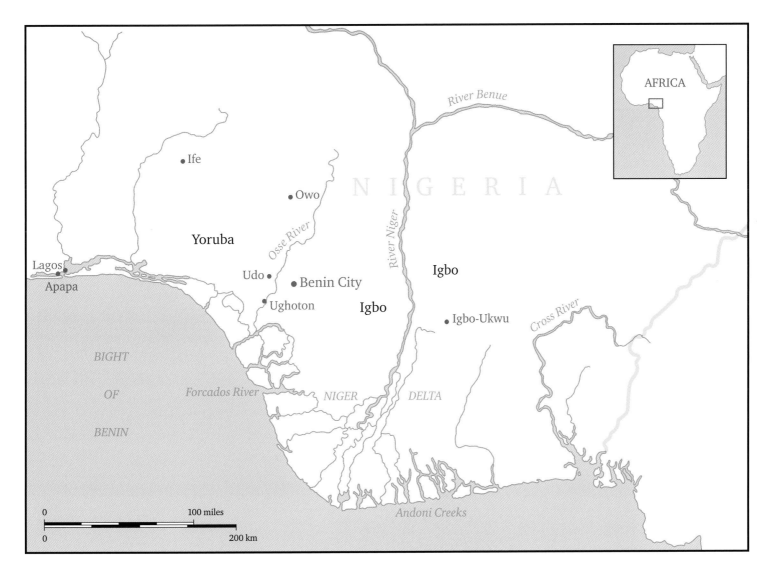

Figure on map labels: River Benue, AFRICA, NIGERIA, Ife, Owo, River Niger, Osse River, Yoruba, Igbo, Lagos, Udo, Benin City, Apapa, Ughoton, Igbo, Igbo-Ukwu, Cross River, BIGHT, OF, BENIN, Forcados River, NIGER, DELTA, Andoni Creeks

0 100 miles
0 200 km

of a heady mix of factual reports, romance and ill-understood but much repeated gossip in which authors freely copied and adapted from each other in the belief that Africa was everywhere much the same; in this the kingdom of Benin was often described. Early chroniclers, primarily Portuguese then Dutch, were impressed by the order and pomp of Benin City, its broad avenues and its royal processions, though internal warfare was a constant menace to the prosperity of the place. Communication with the oba was a very ceremonious affair, with many intermediaries since his subjects and retainers might not look him in the face, nor speak to him directly. He was surrounded by servants and numerous wives and, in later times, was virtually secluded in the palace. One of the fullest descriptions is that of the Dutch chronicler Olfert Dapper in 1668:

FIGURE 2 Map of the Niger Delta area. *The names shown and the designations used on this map do not imply official endorsement or acceptance by the British Museum.*

FIGURE 3 A reproduction of an engraving showing a royal procession, from Olfert Dapper's *Naukeurige Beschrijvinge der Afrikaensche Gewesten*, published in Amsterdam in 1668. This engraving was clearly made by a European artist on the basis of a verbal description (note the leopards shown as wolfhounds) but shows many elements of the court known from later chroniclers, photographs and Benin objects that depict the palace. The towers, with their statues of eagles, are clearly seen in the background.

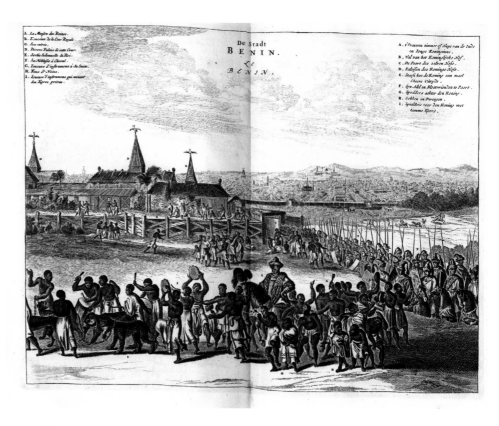

The town possesses several gates . . . The king's court is square, and stands at the right-hand side when entering the town by the gate of Gwato [Ughoton, the port of Benin], and is certainly as large as the town of Haarlem, and entirely surrounded by a special wall, like that which encircles the town. It is divided into many magnificent palaces, houses and apartments of the courtiers, and comprises beautiful and long square galleries, about as large as the Exchange at Amsterdam, but one larger than another, resting on wooden pillars, from top to bottom covered with cast copper, on which are engraved the pictures of their war exploits and battles, and kept very clean. Most palaces and houses of the king are covered with palm leaves . . . and every roof is decorated with a small turret, ending in a point, on which birds are standing, birds cast in copper with outspread wings, cleverly made after living models.

These are the famous brass plaques and birds, which will be discussed later. An illustration from Dapper (Fig. 3) shows the birds *in situ* but also reveals other elements of court life that are depicted by Benin artists, such as horsemen, dwarves and leopards (see Fig. 1). It is important to note that Dapper was merely a compiler; he had never been to Africa himself.

David van Nyendael, an envoy of the Dutch West India Company in 1704, offers another view:

> The king's court, which forms the principal part of the city, must not be forgotten . . . Past this gallery we come to the mud or earthen wall, which has three gates, at each corner one and another in the middle, the last of which is adorned at the top with a wooden turret like a chimney, about sixty or seventy feet high. At the top is fixed a large copper snake whose head hangs downwards. This serpent is very well cast or carved, and is the finest I have seen in Benin. Entering one of these gates, we come into a plain about a quarter of a mile, almost square, and enclosed by a low wall. Being come to the end of this plain, we meet with another such gallery as the first . . . A third gallery offers itself to view, differing from the former only in that the planks upon which it rests are human figures; but so wretchedly carved that it is hardly possible to distinguish whether they are most like men or beasts: notwithstanding which my guides were able to distinguish them into merchants, soldiers, wild beast hunters etc. Behind a white carpet we are also shown eleven men's heads cast in copper, by much as good an artist as the former carver; and upon every one of these is an elephant's tooth, these being some of the king's gods.

Here, then, we have mention of the plaques, the cast brass heads and the tusks, which all form part of the Benin artistic corpus.

Given this early and sustained reporting of Benin's artistic output, it is at first remarkable that it caused such astonishment when finally shown to a wider public. The circumstances were dramatic for, in 1897, the expanding British Empire and the kingdom of Benin collided in the forests, mangroves and inlets of southern Nigeria. In 1892 Oba Ovonramwen had signed a treaty with a visiting British delegation, the sweeping terms of which he clearly did not understand. As oba, he theoretically maintained a monopoly on foreign trade and the treaty obliged him not to interrupt it. This, however, he had repeatedly done, closing it down in a fashion ruinous to foreign merchants operating far from home. For the British at that time free trade was assumed to be natural, almost divine, and they unhesitatingly opposed its restriction wherever they found it. An unarmed diplomatic mission went to urge the oba to comply and was attacked by chiefs acting without royal authority. Over a hundred people were killed. The event was greeted with outrage in London, an expeditionary force of marines and the local Niger Coast Protectorate troops was organized and Benin City was taken within weeks. After Oba Ovonramwen surrendered, he was put on trial and, embarrassingly,

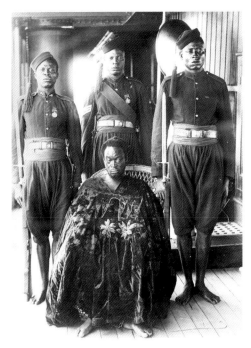

FIGURE 4 This is one of several photographs taken aboard the consular steam yacht the SS *Ivy*, and shows Oba Ovonramwen being sent into exile in Calabar in 1897. Beneath the robe, his feet are chained together. A similar picture was paired with another showing him smiling, and published, captioned as being 'before' and 'after' the verdict acquitting him of murder.

FIGURE 5 A photograph taken by
Dr R. Allman, the medical officer, of
members of the British expedition seated
among the items found on the altars in
the royal palace in 1897. Although most
of the forces were rapidly withdrawn,
Dr Allman stayed on for some five weeks
more and took a number of photographs
that provide us with our best source
of knowledge of the appearance of the
city. Prominent are the carved tusks and
brassware including stools, leopards
and standing figures. At the rear is the
brass roof of a covered gallery, built
around a central courtyard, with a cast
snake running down it (see also Fig. 6).
Other images show that the oba possessed
a large, imported, brass bedstead, equally
a mark of royalty.

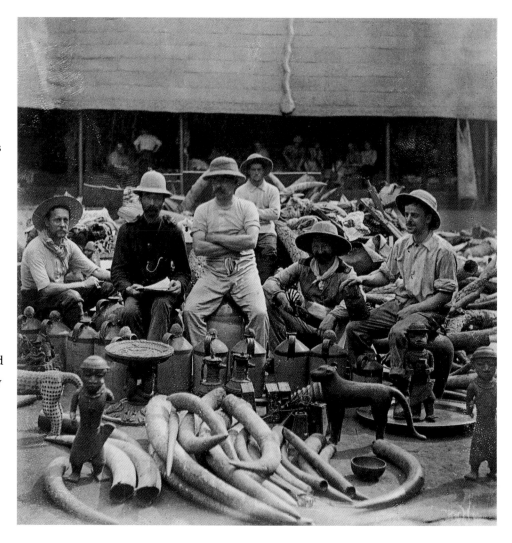

acquitted. Nevertheless, Benin was annexed and the oba sent into exile in Old Calabar
(Fig. 4). The interregnum would last for seventeen years.

What the outsiders found when they arrived both impressed and troubled them. The
royal palace was arranged over a series of courtyards with covered galleries running
around the edges (Fig. 5), just as the chroniclers had described. The mud walls were
elegantly smoothed and polished and decorated with patterns moulded or inlaid with
cowries or painted. Here were to be found the raised altars (Fig. 7), ornamented with
brass heads, carved elephant tusks, cast bells and statues. In a nearby room lay a thousand
or so of the brass plaques, abandoned and covered with dirt, but artfully showing court
officials, animals, battle scenes, Portuguese soldiers and traders, and complex acts of
ritual. The palace itself was undergoing extensive rebuilding. It seems that, in the king's
apartments, some of the beams had been replaced with light girders and others covered

in hammered brass sheeting, while the roofs were made of overlapping layers of sheet brass or galvanized iron. Given the greater availability of imported brass, the plaques were no longer needed.

The objects found on the royal altars and the plaques were removed and sold to defray the expenses of the expedition. This did not imply a high assessment of their artistic value. It was standard military practice to impound bronze and brass as valuable and saleable scrap. Yet when they were exhibited in London later that year, prior to sale, they caused a worldwide sensation. The clearest evidence of their status is perhaps that the metalwork was early named the 'Benin Bronzes', whereas most of it is actually made of brass. Bronze, after all, has connotations of quality, brass of cheap and utilitarian manufacture. They were bought up by museums and galleries and spread around the world, with some pique being voiced by the British at the aggressive buying of the Germans. In London, the war expressed not the new relationship between Africa and the West but that between Britain and a threatening German nationalism.

The price they fetched was not high. These were still 'curios' rather than art – it was the presence of images of Europeans that principally attracted attention – and would not be classed as art until much work had been done, principally by generations of curators at the British Museum. The now priceless ivory pectoral masks would fetch £25. A brass plaque was expensive at £10. Many went unsold.

The problem with the Benin pieces was that, despite the chroniclers, they contradicted everything that was then 'known' about Africa. They were technologically sophisticated and often highly naturalistic, mostly in keeping with Victorian notions of artistic good taste, extremely ornamented yet often elegant. Such images were, in Victorian thought, necessarily a mark of a high civilization. Yet Benin art also bore the ultimate hallmark of savagery, the association with human sacrifice. In 1862 Sir Richard Burton, British consul in Fernando Po, had visited Benin and declared it to be a place of 'gratuitous barbarity that stinks of death'. This was confirmed by the expedition. The surgeon noted:

> As we neared Benin City, we passed several human sacrifices, live women-slaves gagged and pegged on their backs to the ground, the abdominal wall being cut in the form of a cross, and the uninjured gut hanging out . . . As we neared the city, sacrificed human beings were lying in the path and the bush . . . In the king's compound, on a raised platform or altar, running the whole breadth of each, beautiful idols were found. All of them were caked over with human blood . . . Lying about were big bronze heads, dozens in a row, with holes at the top, in which immense carved ivory tusks were fixed. One can form no idea of the impression it made on us. The whole place reeked of blood.

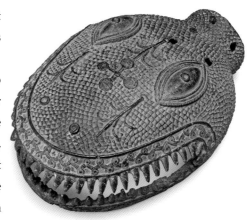

FIGURE 6 Some fifteen snake heads from the palace roofs survive. The body was cast in sections, each attached separately to the roof over a wooden frame, to create a zigzag. The actual species depicted has been contested. For some it is a protective python, for others a threatening puff adder. The ambiguity reflects that of the oba himself.
Head of a snake. Cast brass, 18th century. H. 15 cm, W. 29.5 cm, L. 42.5 cm

FIGURE 7 This is the oldest known photograph of a Benin ancestral altar, and was taken by the 'palm oil ruffian' Cyril Punch. The caption reads, 'Juju altar. King's compound – Benin City May 1891'. Noteworthy are the rounded shape of the altar and the presence of a complex cast altarpiece incorporating several figures, in the centre, flanked by four 'late' heads surmounted by carved tusks. *Ukhurhe* rattle staffs can be seen at the rear. The heads are fixed to the ground by a double-ended stake through the crown which also supports the tusk. Judging by style alone, this must have been an altar to a very recently deceased oba.

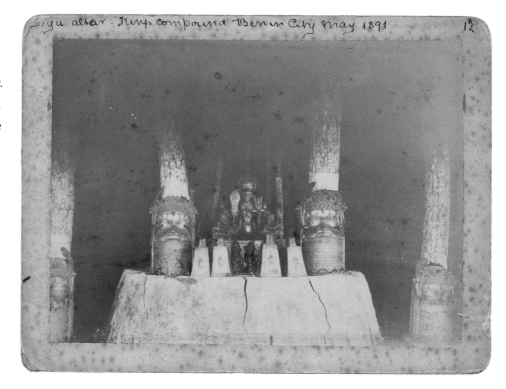

Ironically, much of this bloodletting may have been a final, desperate attempt to mystically repel the British invaders, but the bloodthirsty reputation of Benin would be increased still further in months to come by the publication of lurid memoirs of expedition members, bearing titles such as *City of Blood*. The *Illustrated London News* published a special supplement, written by a correspondent who obliged with thrilling and blood-curdling eyewitness accounts of horror and heroism, even though he did not arrive until all the fighting was over (Fig. 8).

More generally, there was the problem of history. These objects were clearly of considerable age. They were indeed 'antiquities', testaments to a continuity of tradition extending far into the past. Yet the possession of history itself was considered a mark of civilization, so that sub-Saharan Africa, it was assumed, had no history outside the reports of Europeans. For some, the solution to this contradiction lay in the assertion of influence from Ancient Egypt, of which contemporary Benin would then offer a degenerate trace. For others, recourse was had to the images of sixteenth-century Portuguese visitors (Fig. 9), which testified to strong outside contact. These stunning artworks, it was alleged, must have been made by the Portuguese, not the Edo. Sailing ships were, after all, floating artisans' studios with their skills of carving and carpentry, metal casting and scrimshaw working. When it became clear that Benin brass casters were still making such works, it was assumed that the Portuguese must have taught Benin craftsmen any poor,

residual skills they now possessed. Even such enlightened researchers as C.H. Read and O.M. Dalton, who wrote on the early British Museum collection and dismissed wild theories of Indian manufacture, homed in on traditions that stressed heavy outside influence. And auction catalogues always made the link between objects and human death, so that any sword might become an 'executioner's sword', while the large rings (Fig. 35) that decorated the backs of the altars continue to be fancifully 'placed around the neck of the sacrificial victim' up to the present day.

Older historians have tended to see the British incursion simply as a military and economic act but, for the Edo, it had important mythical implications. Europeans had long been associated with the white-faced god Olokun, who sent wealth and children from below the sea. There he lived in state as the counterpart of the terrestrial oba, with a palace, retainers and regalia that matched his own. The Edo had always seen themselves as a forest people and disliked even internal waterways, shunning the coast and preferring to interact with it through foreign intermediaries who might ultimately become subjects of client states. European merchants were classed as messengers of Olokun. They entered the kingdom at Ughoton, the port of Benin and the centre of Olokun worship. At various periods they resided there permanently and, when they left, they were seen to sail away and disappear over the horizon, or, in the eyes of the Edo, retreat beneath the sea. The punitive expedition followed the same route as the traders and it is significant that when Oba Ovonramwen signed the treaty of 1892 with the British, he remarked offhandedly that matters remained unchanged by it as Olokun still ruled the sea and he, the oba, the land. Obas were specifically forbidden to cross large bodies of water, as to do so was to enter Olokun's realm, or to die. Indeed, a poetic way of stating that a king had passed away was to say 'the sun has gone down into the sea'. To put the oba aboard the SS *Ivy* and send him into exile over the water to Calabar, as the British did (Fig. 4), was thus symbolically to kill him.

THE INTERNAL HISTORY OF BENIN

Benin genealogies begin with the Ogiso, a dynasty shrouded in mystery, which was replaced by Oranmiyan, a ruler of neighbouring Yoruba origin who establishes links with the mythologically important city of Ife. For Yoruba, Ife is the centre of the world and the origin of all kingship. The first Portuguese visitor to Benin was probably Afonso de Aveiro in 1486, during the reign of Oba Esigie. Trade with the newcomers briefly flourished through the export of pepper, raffia cloth, ivory and slaves, but Benin was not a sustained exporter of the male slaves preferred by the internal African market, finding greater profit in using their labour on its own slave plantations cleared from the forest. Land was plentiful, manpower in short supply. Benin envoys were received in Lisbon and missionaries sent so that, by 1538, Edo children were being educated in Portuguese in the royal court and

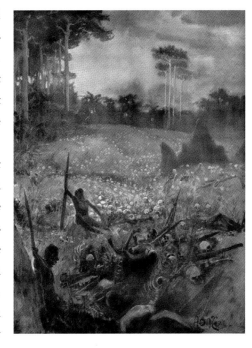

FIGURE 8 This drawing was produced by H.C. Seppings Wright, special correspondent of the *Illustrated London News*, for its Benin Supplement of 27 March 1897. Its wild poetic licence provided images that associated the Benin human sacrifices with the death of Jesus Christ, strengthened by the fact that several crucified figures were found by the troops. Seppings Wright's 'eyewitness' drawings are as little to be taken literally as the Benin plaques showing scenes of warfare. Benin sacrifice and execution (the two not always being distinct) took various forms – disembowelment, crucifixion, strangulation, a powerful blow to the back of the head or decapitation – and much play was made of a young Kru boy extracted from beneath a pile of corpses who recovered but was henceforth insane.

FIGURE 9 Figures of this kind were
used to ornament the royal ancestral
altars as a statement of the oba's power.
Portuguese mercenaries are said to have
fought alongside Benin forces in the
sixteenth century. This soldier carries a
matchlock rifle. Noteworthy features are
the extremely careful observation of
dress and equipment combined with the
portrayal of the figure as going barefoot.
The active stance is most unusual in Benin
art but, even on the plaques, Europeans
may be shown in asymmetric poses
whereas African figures are generally
portrayed frontally and static, like the
priest or crossbearer figures (Fig. 65).
Eighteenth-century castings of boxes in
the form of the oba's reception hall show
two large images of soldiers in this same
pose standing on the main roof beam.
Presumably these were made of carved
wood overlaid with hammered brass,
though they may not be shown to scale.

In contrast to Fig. 96, this work shows
the heaviness and elaboration of the later
castings, especially the square base with
its ornamentation and images of weapons.
It combines elements that are unlikely
to have been actually seen together. The
musket and pistols are flintlocks, and
so date from at least the late seventeenth
century. The weapons on the base are
eighteenth- or nineteenth-century; the
dress is fifteenth- or sixteenth-century.
*Figure of an armed Portuguese soldier on
a square base. Cast brass, 18th century.
H. 42 cm, W. 19.2 cm, D. 19.5 cm*

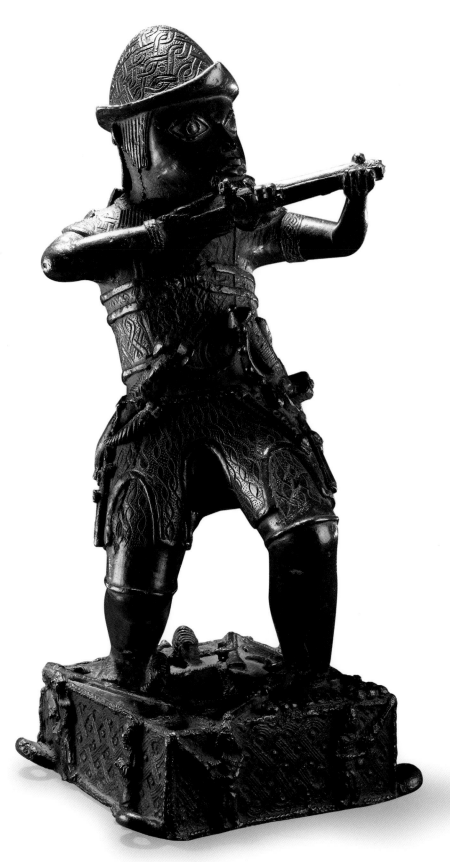

the oba himself, allegedly, had been baptized. This had important legal implications since, by papal order, only Christian peoples might be sold guns. In the fifteenth and sixteenth centuries Benin underwent steady expansion under its warrior kings, Ewuare, Ozolua, Esigie, Orhogbua and Ehengbuda. Ewuare is credited with a complete restructuring of the kingdom at every level, both political and ceremonial. He laid out the basic plan of Benin City on its current site, divided it into town and court and the different craft quarters, and constructed a palace in the new Yoruba style with polished mud walls and central courtyards. He is credited with setting up the annual cycle of rites that continues to structure the mystical life of the kingdom.

But it was the reign of Esigie in the early sixteenth century that was most characterized by conflict and by the use of Portuguese armed mercenaries in Benin forces. First there was a struggle for power between Esigie and his brother Aruaran, who based himself in the town of Udo, some twenty miles north-west of Benin City, and began casting his own brass heads there (Fig. 20). When that had been resolved, war broke out with the northern neighbours, the Igala, ending in their subjugation as a vassal state, thanks in part to the intervention of Esigie's mother, Idia, who fought for her son both supernaturally and with an army. This period, until the end of the sixteenth century, is remembered as something of a golden age, with a flourishing of arts and trade, and it is conventionally accepted as the time when brass casting was at its height. Esigie's heirs extended the borders of the kingdom as far as Lagos but, when Ehengbuda (acc. *c.* 1578) was drowned there, the Edo turned their backs once more on the sea, and it was determined that the oba should no longer lead the army personally but withdraw within the palace. This set the scene for the emergence of powerful warchiefs and enmeshed the oba in a tightening web of ritual and ceremonial obligations while the vestigial Christian influence withered away.

The seventeenth and eighteenth centuries saw great internal strife, and the Portuguese were replaced by other outsiders: Dutch, French and English. Rebellions and inheritance disputes still racked the kingdom. Finally, in the early eighteenth century, it was established that only the eldest son was a candidate for the Obaship while the *ezomo*, the dominant palace chief, should henceforth lead the army with other powerful titleholders, of different loyalties, set as commanders under him. But this did not put an end to factional disputes, and outlying districts asserted an increasing autonomy. The oba continued to exert his control increasingly through ritual and mystical force, more and more secluded in the royal palace. It is perhaps significant that it was Oba Eresonyen (acc. *c.* 1735) who forbade the village masking cults henceforth to enter Benin and established in their place the festival of Ugie Ododua, which stresses links with the kingdom of Ife rather than the surrounding countryside. Village cults typically celebrate rebels and heroes who fought against the central power of the oba, and many have sunk into the earth to become part of the very landscape outside the capital.

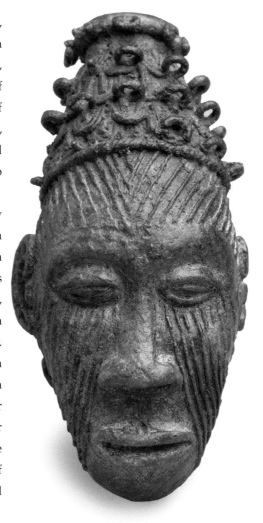

FIGURE 10 This is from a large cache of bronze objects unearthed at Igbo-Ukwu, some 200 kilometres east of Benin City, shortly before the Second World War. Subsequent excavations in the 1950s found a wide range of material over a large site, which has been linked with a priest king. The date establishes a local metal-casting technology several hundred years before European contact.
Pendant in the form of a human head.
Ibo people, Igbo-Ukwu, Nigeria. Bronze,
10th century. H. 8 cm, W. 4.5 cm, D. 5.5 cm

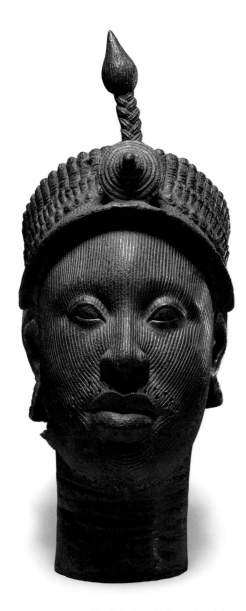

The nineteenth century is seen as a period of decline under increasing European pressure as the familiar problems of internal dissent and succession disputes continued to sap the kingdom. Benin was driven back to its original borders. The different signs of Benin suzerainty – use of regalia, confirmation of new rulers and the exaction of tribute and military levies – can never have coincided among the peoples it dominated. The trade in slaves had been replaced by that in ivory and palm oil to lubricate the new age of steam, and global trading networks reached out impatiently towards the forest products of Benin. For centuries the oba had sought to attain, maintain or regain control of foreign trade and, from the fact that the palace was being expensively rebuilt in 1897, largely in brass, it is clear that this source of luxury goods was still being obsessively harnessed to royal and ritual concerns. Oba Ovonramwen had asked the diplomatic expedition attacked by his warchiefs not to come, as he was too busy with ceremonies to see them.

METAL CASTING IN THE LOWER NIGER DELTA

Until the 1950s Benin scholars were obsessed with a single question: who really made the Benin Bronzes? They did not have the advantage, as we do now, of knowing of rich local traditions of metalworking going back long before the arrival of Europeans on the coast of West Africa. Although much research remains to be done in the archaeology of the Niger Delta, objects from Igbo-Ukwu carry back the casting of copper alloys to at least the ninth and tenth centuries. The heads, with their facial scarification, attached bells and rings for hanging around the neck, recall pendant forms to be found later in Benin on the other side of the Niger, suggesting possible influence (Fig. 10). Another skilled casting tradition is now well documented from the Yoruba city of Ife, under a hundred miles to the west of Benin City. Here, between the eleventh and fifteenth centuries, brass heads and statues were produced which excel even those from Benin in their easy naturalism (Fig. 11). Moreover, intermediate forms mixing Ife and Benin styles and subjects have been found, which reinforce a local oral tradition that brass casting came from Ife, a tradition reflected in the sharing of many deities and religious forms between the two peoples. In addition there has emerged a mass of as yet ill-understood smaller casting traditions of the Delta that have been lumped together under the name of the Lower Niger Bronze Industries (LNBI) and whose precise relations with Benin are yet to be clarified (Fig. 12). Ife metal castings are mostly leaded brass (copper plus zinc) whereas Igbo-Ukwu and LNBI castings are mainly bronze (copper plus tin). Benin castings begin as bronzes while later works are made of imported brass. So, while problems remain with the simple assumption of the transmission of casting knowledge from one to the other among these traditions, it seems inevitable that some relationship existed. And while clear evidence of foreign influence is to be found in the Benin corpus, there is no need to assume anything but a purely African origin for the technology of metal casting in Benin.

FIGURE 11 On this head, found at Ife, traces of red pigment can still be seen on the 'crown'. Holes have been pierced around the mouth, probably for the attachment of a beaded beard. It is likely that this was a funerary image and may have been attached to a wooden 'body' by a hole made in the neck.
Head of an Oni (ruler). Yoruba people, Ife, Nigeria. Cast brass, 12th–15th century. H. 35 cm, W. 12.5 cm, D. 15 cm

All these casting traditions used the lost-wax technique. The desired object is fashioned in wax over a clay core and covered with another layer of fine clay. The whole is baked so that the wax melts and can be poured out to leave a space in the precise shape of the wax model. Into this, molten metal is poured and the whole is allowed to cool. The outer shell can then be broken away to reveal the metal casting beneath. In this technology excellent results can be obtained but, since moulds cannot be reused, each object is unique.

More interesting is the general role of copper and its alloys in the cultures of the area. Copper alloys were important items of trade and highly valued. In African languages copper is often known as 'red gold', red being the colour of power, blood and danger. To supplement local sources, it had to be imported across the Sahara but, after contact with the fifteenth-century Portuguese, it was brought in large quantities by sea, usually in the form of copper and brass manilla bracelets and rods. In the sixteenth century the price of a slave was between twelve and sixteen manillas and a single vessel might be carrying 30,000 of them to fuel the palace workshops. In Benin foreign copper was intimately associated with kingship. Brass objects, apart from trivial bracelets and bells, were a royal prerogative. No one else might possess them except with royal permission and outside trade goods were regarded as no more than the raw material of ritual. Finished brass objects might be given out to important officials but must always be returned on their death; accidental loss of regalia was a capital offence.

In Africa technologies are traditionally sex-specific and carry with them a whole implicit philosophy. So potting is a female skill and seen as reflecting the powers of women and their bodies. Metalworking, on the other hand, is exclusively masculine and its hard, shiny, virtually indestructible images, on the altars and in the rituals, are an idiom in which statements about the mutability of kings but the endurance of male kingship can be made. Benin was a city in which the royal palace was literally constructed of brass, and it seems clear that, for centuries, it acted as a centre for the circulation of brass and bronze objects within and without the kingdom, distributing them to vassal rulers and chiefs and taking them back from conquered peoples as the visible sign of royal authority.

THE ORGANIZATION OF THE KINGDOM AND THE INTERPRETATION OF OBJECTS

The creation of images was not just an aesthetic matter but one with legal and metaphysical implications. The most important act of respect for an eldest son was to establish an altar, with appropriate objects, to his deceased father: to 'plant' him and retain links with him through regular offerings. The dead continue as part of the community and it is significant that the most important social links are through men. In the villages it is the oldest man – the one closest to the ancestors – who is given the crucial power to allocate communal

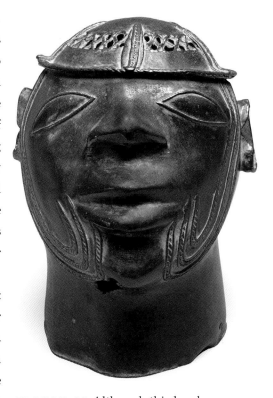

FIGURE 12 Although this head was found at Benin, it is stylistically very different from the mainstream tradition. It is a very light casting and its sinuous curves and idealized forms, recalling art nouveau, are typical of the clutch of traditions lumped together as the Lower Niger Bronze Industries, in that their precise place of origin, date and relations with each other are still obscure.
Head showing facial scarification. Lower Niger Bronze Industries. Cast bronze, ?16th century. H. 27 cm, W. 10 cm, D. 21.2 cm

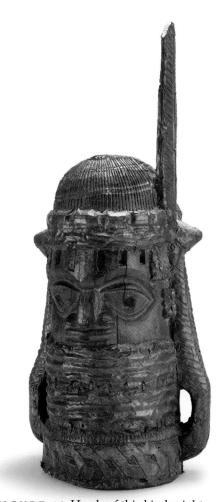

FIGURE 13 Heads of this kind might
be made either for the altars of dead
chiefs or function as 'shrines of the head'
through which a man's head might
be strengthened by offerings. The use
of riveted brass sheeting in this fashion
was a concession granted to important
chiefs in the nineteenth century and
owes much to the new ready availability
of the material as a Western import.
*Head. Wood, covered with hammered
brass, 19th century. H. 59.3 cm,
W. 23.6 cm, D. 21.5 cm*

land. Like most kingdoms, Benin was obsessively hierarchical and great differences of elaboration existed between the shrines to dead commoners, chiefs and obas. One expression of this was a hierarchy of materials. Brass was a royal material, so only royal altars might sport cast brass objects, especially heads. Chiefs' altars had heads of wood, in later times covered in brass sheeting (Fig. 13), and brass casters had heads of terracotta (Fig. 22). Commoners only had small, generic images of heads on the ends of the wooden rattle staffs (*ukhurhe*) that are struck on the ground to mark an offering (Fig. 90). A hierarchy of substances is something of a theme in Benin art, with what is basically the 'same' object being executed in different materials according to rank. Yet, paradoxically, the sculptures of the most powerful beings, the gods, were located in their major shrines outside the city and were fashioned in simple mud.

It was the establishment of the altar to one's predecessor that provided the formal and public legitimation of succession between the generations. When the commemorative head is made for his father, a new oba touches the brass caster's tongs at the moment of the pouring of the molten metal, as if he himself were making the head. In 1897 there were said to be seventeen royal altars within the palace, so those of some rulers had clearly fallen into disuse or been collapsed together. Unfortunately, no record was kept of what was on which altar before they were disturbed and over a century of Benin scholarship has sought in vain to rectify this.

Brass was not the only royal material. Benin court art often uses ivory. One tusk of every elephant killed in Benin territory was owed to the oba and, since ivory was hotly sought after by Europeans, this enabled him to dominate trade. In the eighteenth century a visitor to Benin was shown a courtyard of the palace which contained over 3,000 large tusks. The introduction of firearms had somewhat simplified hunting. Although the primitive smoothbore weapons available were not able to kill an elephant outright, they could be adapted to fire poisoned darts that would bring it down over a matter of days as it was tracked through the bush. It is noteworthy that when Benin antiquities were auctioned in the West, the tusks fetched far higher prices than any of the brasswork. As her part, Queen Victoria was sent two ivory leopards (Fig. 79).

To supplement local supplies of red agate, the king might also choose to receive imported red coral of Mediterranean origin, another royal prerogative, since Benin legend tells of an epic raid by Oba Ewuare, in the fifteenth century, on the realm of Olokun, in which he stripped the god of his coral and other luxury goods. One of the marks of a major chief is still the wearing of a stiff necklace (*ikele*) of cylindrical coral beads threaded on wire. Royal materials were not simply expensive and therefore a sign of wealth. Often they were imbued with *ase*, a performative force with the power to convert words into facts, useful in both blessing and cursing.

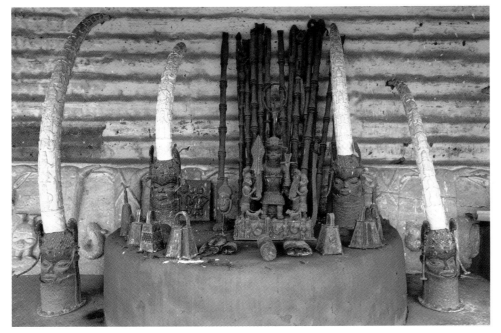

FIGURE 14 Photograph of the altar of Oba Ovonramwen, taken in 1970 by Eliot Elisofon. This was one of the first altars to be rehabilitated after the restoration of royal rule in 1914, though many of the works may be of later manufacture. After a theft in 1975, new photography of the altars was no longer permitted. The altar holds many traditional forms – the large brass heads, rattle staffs, carved tusks, etc. – but executed in a heavy, modern style, while the tusks are smaller than would have been the case in earlier centuries. The grooved wall design at the rear is a prerogative of the royal palace.

All such objects were made by the palace guilds, which strictly organized craftsmen under royal patronage. The palace was classically a complicated mix of titles, societies and associations, the main building being divided among them so that only the oba had access to all parts. Guilds still belong specifically to one of the three main associations of which, in theory, all free males throughout Benin territory were also nominally members. Thus the brass casters' guild belongs to the Iwebo, or Palace Society, which controls some twenty others – dancers, drummers, ivory and wood carvers, leather workers, leopard hunters, astrologers and priests – supervised by titled chiefs, while other associations are responsible for personnel as diverse as eagle hunters, doctors, anti-witchcraft sorcerers and acrobats. To this day guilds and associations are jealous of their secrets and privileges and constantly jostle for status. In pre-colonial times objects were produced to royal commission only and raw materials were supplied by the court. A guild is responsible for maintaining standards and training apprentices and a special altar is maintained for its founder. The brass casters also keep a shrine to Ogun, the irascible and dangerous god of metal. While small objects may be cast individually, larger pieces would involve many stages and many different hands, in a studio-type mode of production, the workers being divided up into three ranked age-grades.

Ivory and wood carvers form a single guild and now members work in both materials. Ivory workers were always permitted some outside patronage. High-ranking chiefs might receive permission to have tusks on their ancestral altars, but restrictions would be placed on the degree of carving and the patterns allowed, whereas the Afro-Portuguese ivories, made as souvenirs for foreigners to take away, had no known domestic buyers.

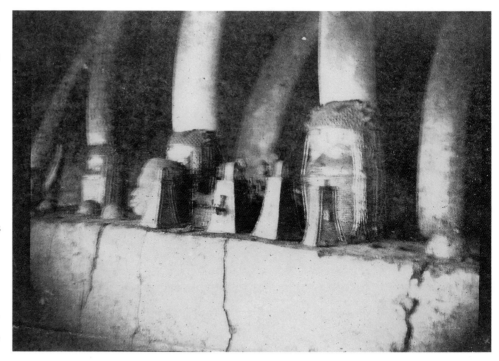

FIGURE 15 This photograph by Dr Allman of a royal ancestral altar appears to show an 'early' head alongside eighteenth-century heads and might well argue against the standard dating criteria. We should note, however, that the head is clearly out of place. It faces sideways and disrupts the neat arrangement of the other objects. In 1919 Felix von Luschan published two similar heads, displayed on a 'totem pole'. It is astonishing that scholars have taken the latter image seriously. Closer examination of it shows that the heads have been crudely dumped on the dishes of oil lamps. Clearly, the heads had been disturbed and whimsically relocated.

Objects made for ritual use and subject to the public scrutiny of elders might be expected to be inherently conservative and resistant to change. This does seem to have been the case. In the palace craftsmen would have their models constantly before them on the altars and in rituals, and deviations from the norm would have to fight for acceptance. Yet changes in the corpus of objects do occur and have to be considered as deliberate innovations, responding to new needs and opportunities. That even metal castings do not use moulds and are unique items has always allowed some variation. Since the opening up of the palace workshops in the 1920s to outside commissions, forms and styles have proliferated and links with the palace have inevitably weakened, so the present oba orders his brass-work through the Benin Traditional Council and pays for it in cash, like any other customer. While some casters retain links to the guilds, others have no traditional connection with them at all, so centralized control no longer exists. New and more monumental works were favoured, provided for by the large quantity of brass shell cases left over from the Biafran War, while Western dealers have urged a return to more ancient forms that may or may not be acknowledged as reproductions rather than antiquities. Naturally all this has fed into the brasswork displayed on post-restoration altars (Fig. 14).

THE BENIN CORPUS AND THE INVENTION OF ART HISTORY
Just as the scholarship of the first half of the twentieth century was obsessed with the ethnic origins of the Benin Bronzes and other artworks, so that of the second half has endlessly

reworked their relative chronology to make them digestible by art historians. The corpus has been repeatedly divided up into a proliferation of styles and sub-styles, periods and even postulated individual hands. The basic framework in all this is provided by the writers of dated chronicles who recorded what they saw in Benin City at a specific time so that a sequence can be constructed, leading up to what was found there in 1897. So we know from Dapper's description of the palace that the plaques were in place by the mid-seventeenth century, but cannot know for sure how old they were then, and from 1897 that they had been discarded and were no longer made, but we cannot be certain when this change occurred. Inevitably, problems of interpretation arise.

That objects are not mentioned is no proof that they were not there; they may simply have passed unseen. The first description of carved tusks on altars is by a French visitor, Jean-François Landolphe, in 1778, but Nyendael had seen tusks on altars in 1704 without mentioning any carving. Is this evidence of their existence at that date or not? It has been convenient to assume that simple, light heads such as Fig. 23 are relatively early since they are most like the naturalistic heads from Ife and least like the heavy, complex castings being made in 1897 (Fig. 26). Other heads and castings – and, with greater difficulty, works in other media – can then be compared with the putative series of heads and also arranged in some sort of order by their similarity to them. So Fig. 24, being intermediate in style between the two extreme kinds of heads, would be a commemorative head of 1550–1650.

Such a sequence has been notoriously subject to challenge and throws up anomalies, some less real than they seem (Fig. 15). One way of dealing with more substantial oddities has been to reassign works as not part of the Benin corpus, despite being found in the city in 1897. Thus, although castings of mounted horsemen are well known in Benin, Fig. 16 is stylistically unlike other horseman figures such as Fig. 33, and more closely resembles works of the Lower Niger Bronze Industries in its vestigial limbs and bulging eyes, so it is assumed to have been imported. The process works in both directions. The Apapa pectoral (Fig. 17), although found in Lagos, far to the west of Benin City, might still seem to closely resemble classically Benin works and so can be called an export. Or perhaps we could refer it to the Yoruba city of Owo, which had strong links with Benin, shares a title system with it and may have produced brass works in this style. Certainty is impossible.

With the development of new and sophisticated archaeological dating techniques, research laboratories around the world have hastened to use them on the Benin corpus to complement stylistic analyses. First, there are analyses of the metal of which the Benin Bronzes are composed. Here the most telling component is the percentage of zinc. Metallic zinc could not be produced before the nineteenth century, and this is a necessary stage in the production of brass containing more than thirty per cent zinc. It is assumed that this would be recognized as desirable since it is a cheap metal which drastically cuts the price of copper

alloys. So we can suppose that works with more than this proportion of zinc were not made earlier than the nineteenth century and, possibly, that zinc percentage will increase over time.

The second technique is thermoluminescent (TL) dating, which uses the fact that some minerals trap ionizing radiation over time. When heated, they release this in the form of light so that calculations can reveal how long the material has been exposed to radiation since it was last heated. Since many of the Benin Bronzes retain traces of the clay core over which they were modelled, examining a sample of this offers a means of directly dating the moment they were fired. However, since the technique works best with samples of great archaeological age and exhumed in known conditions, its results when applied to Benin material have been deeply disappointing. Partly this may derive from the fact that a section of the city, containing the Bronzes, was accidentally burnt down in 1897. In other words, the TL clock of many of the Benin Bronzes was reset at zero. Even had this not occurred in 1897, Benin local history reports that the palace had previously been burnt down twice and looted once.

Given the unsatisfactory nature of these various dating procedures, conclusions drawn this far are decidedly rough and ready. It does seem that the bigger and heavier the cast metal pieces, the later they are in date. When metal is precious, having been transported across the Sahara Desert, it makes sense to cast it as finely as possible. The change from bronze to brass would seem likely to correlate with the arrival of the Portuguese and large quantities of their new, cheaper alloys. The increasingly heavy modelling with more post-firing finishing also suggests the availability of Western metalworking files, which replace the abrasive leaves used by earlier artists.

More recently researchers have focused on another source of information: the oral traditions of the Edo themselves. Over the years several local historians specializing in this kind of information have emerged and researchers have drawn on a small number of informants within the palace and guild system. These Edo tend to see the royal art of Benin as a historical archive. The plaques especially are looked at rather as one would look at a photograph album of particular shots of particular people at a particular historical moment in the past. Nowadays casters may indeed work from a photograph to produce a plaque to commemorate a particular event, complete with a cast picture frame, while informants questioned by researchers will be shown not actual plaques but photographs of plaques. Unsurprisingly then, Edo today may even refer to historical plaques as 'our snaps'. Individual 'characters' are identified by name, participating in specific events. Yet this does not mean that they are seen as physical 'portraits'. In Benin art, faces are highly stylized. On any plaque, everyone has the same face, just as even the most naturalistic brass heads all resemble each other. Despite modern trends in interpretation, it is much more likely that the figures on plaques were originally generic, rather than referring to known people, while, on the altars of specific obas, it was not the individual piece that represented the ruler but the whole installation. It can be argued that the motifs of the carved tusks (Fig. 34) are much more effective in identifying a particular

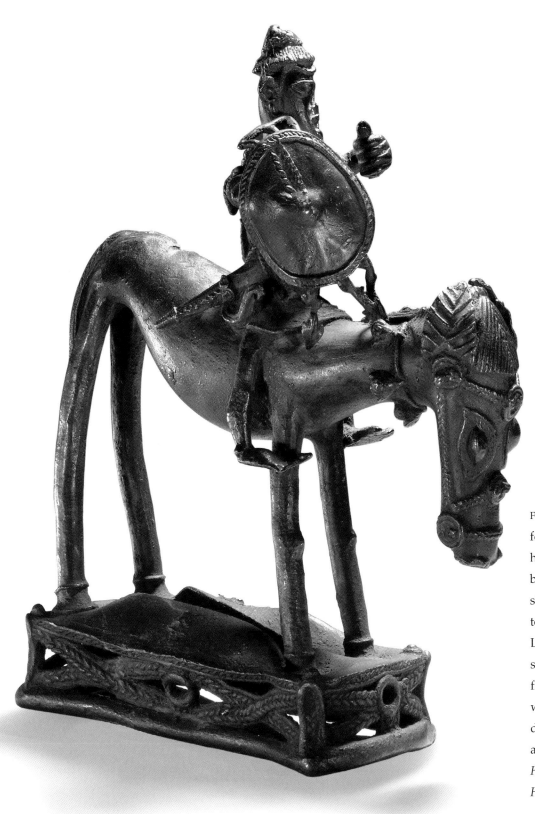

FIGURE 16 This appealing figure closely follows the iconography of the Benin horsemen in its pose, dress and arms but is executed in a radically different style, with the bulging eyes and concave toenails that are a curious feature of some LNBI castings. It is totally without the sophistication and accomplished surface finish of Fig. 33, but we are unable to say whether this contrast is primarily due to differences of origin, period, function, artistic sensibility or technological resources. *Horseman. Cast bronze, ?16th century. H. 27 cm, W. 9.5 cm, D. 21.5 cm*

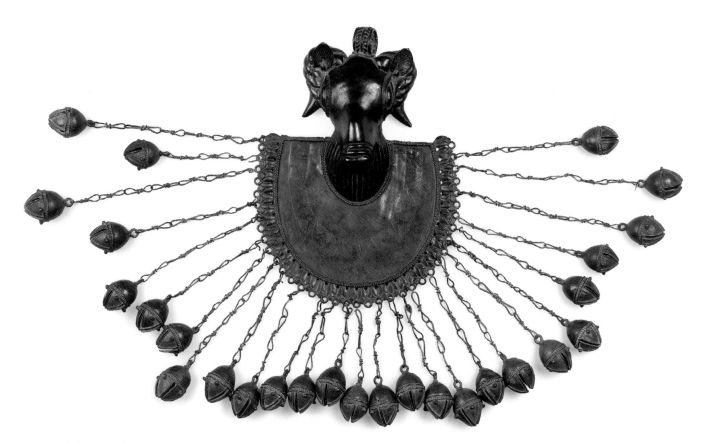

FIGURE 17 This magnificent piece was unearthed in 1907 at Apapa, Lagos, as part of an extensive hoard of brass- and bronzework. It is a casting of subdued elegance and strong modelling. The central, semicircular panel has been etched with geometrical decoration and edged with cast plaitwork and the horns have been artificially spread to artfully frame the central face. The suspension loop is also decorated with plaitwork in what is a very thin and technically accomplished casting. Rams signify royalty in both Benin and Yoruba art.
Pectoral mask in the form of a ram's head, Cast brass, with large bells attached by hand-drawn wire. ?15th/16th century. H. 43 cm, W. 12.5 cm, D. 6 cm

oba's shrine than the commemorative heads that supported them. Objects might also be added or removed. There is no reason to assume that installations were stable over time.

The Edo of the palace have developed a vigorous oral folklore which associates changes in regalia, ritual practice or historical events with specific obas. Once such a distinguishing feature is found, consulting a reconstructed list of kings can then provide an approximate date for the works showing this individual and this feature. Thus, according to tradition, the cult of the Queen Mother, with her separate court at Uselu, was begun by Oba Esigie (*c.* 1504–50). The 'early' (i.e. light and naturalistic) castings of a Queen Mother (Fig. 68) are therefore assignable to this period and identified as his mother, Idia.

What has emerged is a version of Benin history that sees art as being tied up with politics. The plaques are seen as being cast some time between 1550 and 1650, under Oba Esigie, with the kingdom flourishing with the new coastal trade. This golden age for the arts ended when Oba Ohuan died without an heir. With a loss of legitimate authority at the centre, Benin was plunged into internecine war and artistic endeavour declined until Oba Ewuakpe (*c.* 1700) restored the power of the kings, repaired the palace and refurbished the ancestral altars. Around 1713 he was succeeded by Akenzua I, who also enriched the kingdom with trade and commissioned new types of sculpture for the altars. Eresoyen (*c.* 1735), continuing the work of his predecessor, also greatly elaborated the mystical and ritual focus of the court.

Part of this was the addition of large brass figures, multi-figure brass altarpieces and carved tusks to the displays at this period. The nineteenth century again brought political turmoil and artistic decline. Shortly before he was exiled, Ovonramwen had either killed several chiefs or ordered them to commit suicide. Naturally, in accordance with academic fashions, other versions of Benin history have sought to show artistic efflorescence not as a mere reflection of the kingdom's economic and military strength but as exerting an active force on political events.

Yet difficulties remain. The plaque in Fig. 40 shows an oba with his legs turned to mudfish. According to legend, Oba Ohen (acc. *c.* 1334) sought to hide his crippled legs from his subjects by claiming such a mystical transformation, which identified him with the sea-god Olokun. The deception was detected and he was slain in a palace revolution after he had committed the ultimate crime of executing his own *iyase* chief. Therefore such a plaque should be datable to after the early fourteenth century. But this is unhelpful, for this date, while not certainly incorrect, is far earlier than that assigned to the creation of the plaques (*c.* 1550–1650) and warns us that images of one period may well be called up for use again, even hundreds of years later. The idea of an oba who failed in his duties to his chiefs and people and paid the price might well be felt to have a lasting relevance in court circles. It might seem strange that such an image would be displayed at court but it must be remembered that, since Ohuan was an only child who died without issue, these plaques were commissioned by successful usurpers. Or this may be simply a conventional and generic image that shows the identification of the terrestrial oba with the sub-aquatic god Olokun. Such interpretations are in danger then of assuming a false unanimity among informants, and really only tell us one of the various ways in which such objects may be seen today and not necessarily anything reliable about the context of their creation. What remains true is that, when looking at the classic art, we should not expect to see depictions of living individuals in a culture that associated the making of images with death. Throughout the Delta area the paintings of living rulers that Europeans brought with them were always seen by Africans as shrines of dead ancestors. The photographing of Oba Ovonramwen in 1897 (Fig. 4) would have been just another form of inflicted symbolic death.

After the long interregnum in 1914 there was a conscious attempt to refound the kingdom – the first ruler became Eweka II in emulation of the dynasty-founding Oba Eweka I – and much creative invention and forgetting took place to strengthen the myth of dynastic continuity. Much of the motif-spotting that goes into the present interpretation of Benin works looks suspiciously like the sort of art-historical connoisseurship favoured by Western art-school-trained researchers, and a subtle and curious circularity may well be developing. The current oba of Benin, after all, has a large library of books written by Western researchers on Benin art and a tape of the David Attenborough *Tribal Eye* video to hand, while every brass caster has his copy of the latest Christie's auction catalogue. Benin City now boasts its own university-trained art historians and is no longer a remote place peopled by 'naive' local informants.

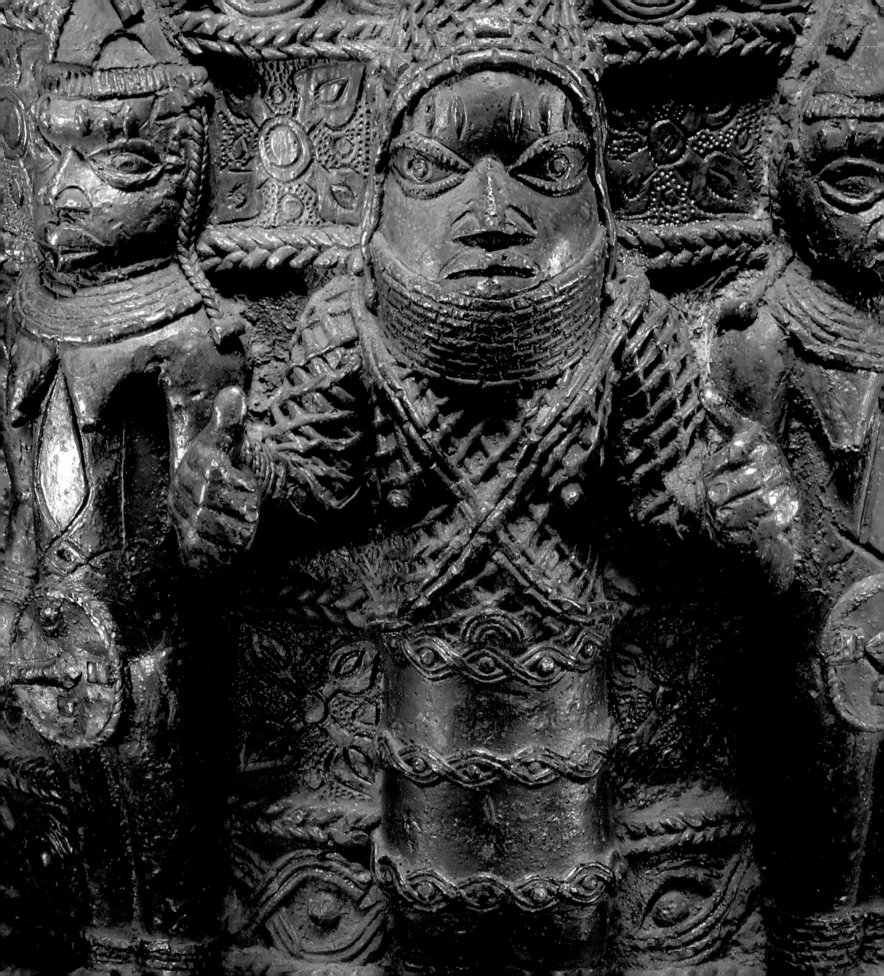

CHAPTER ONE

HEADS AND HANDS IN BENIN HEARTS

THAT THE BENIN HEADS HAVE BEEN SO PROMINENT IN THE DISCUSSION OF THE KINGDOM'S creations may simply reflect the West's historical obsession with the depiction of the human form in art. Liturgically the most important objects on the altars are not the heads but the *ukhurhe* rattle staffs, which are the functionally indispensable element. So it would be wrong to see the heads and other brasswork as inherently sacred. They are signs of wealth and royalty rather than divinity, as can be seen from well-documented cases of obas casually removing them from altars to present to passing European visitors as souvenirs. The presentation by General Gowon, President of Nigeria, of a Benin head to Queen Elizabeth II while on a state visit in 1973 merely continues the tradition.

Yet heads are important in Benin thought. The heads of enemies were removed and brought back to the city, allegedly to be cast in brass. The circulation of brass heads was

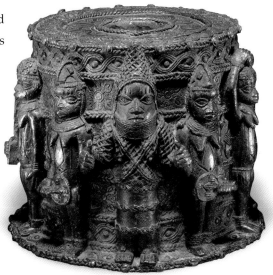

THE POSSESSION of brass objects like this signified both royalty and honorary masculinity, and was only permitted to obas and, occasionally, very powerful chiefs and Queen Mothers. The central figure is a Queen Mother showing both thumbs in a characteristic gesture often portrayed on such altars. She is flanked by female pages that correspond to the male *emada* of the oba, holding circular fans of hide and felt. Ornate bands of cable- and plaitwork, executed in thick and heavy relief, punctuate the surface. In the centre is a hole that would probably have held a small tusk.

FIGURE 18 *Altar of the hand for a Queen Mother. Cast brass, late 18th century. H. 20.5 cm, W. 25.3 cm, D. 26 cm*

an important mark of political power. And a whole philosophy accompanies the making of heads. The head is the seat of judgement and will, of thinking, seeing and hearing. A responsible Edo man will ceremonially strengthen his own head with offerings and thus protect his wives and children. The oba too performs this ritual at the annual ceremony of Igue, and it is particularly important that he should do so, for the general well-being of his entire people and the state depend upon it. It is this ceremony that particularly makes the Obaship a divine kingship. The oba is a supernatural being requiring neither sleep nor food, and in former times Igue involved the death of a slave or prisoner to 'feed' his head, only the oba having the right to shed human blood in this way.

Apart from the tusks and the heads, another class of object particularly struck the Europeans: large cylindrical pieces, set on a square base and ornamented with all kinds of figures (Figs 18 and 21). In the auction catalogues they inevitably became 'executioner's blocks', but in fact they were *ikegobo,* altars of the hand. According to traditional Benin notions of the body, the head is opposed to the hand. Important men and very high-ranking women may have material representations of both their heads and hands, through which they may be strengthened by smearing the objects with sacrificial blood. The same hierarchy of wood, terracotta and brass, according to status, reigns here as in the making of the memorial heads (Fig. 19). In the case of chiefs, shrines of the head are identical to the wooden memorial heads placed on ancestral altars but, in this case, kept concealed at the rear of the house. It is these heads that are ritually more important.

Head and hand interact with yet another force, the *ehi.* Tradition relates that, before a person is born, they must kneel before Osanabua, the creator, and agree the general course of their life, their destiny or *ehi.* At the end of the interview Osanabua bangs his staff on the ground and the matter is set. Stories tell of the misery of those who seek to defy their own destiny. The *ehi* is thus part of a trilogy of important explanatory concepts whose interaction renders reasonable the different and unpredictable fates of men. Because of bad *ehi,* or bad head, or bad hand, a person may make enormous efforts and still not achieve what they deserve.

When a man is incarnated in this world, his *ehi* double stays behind in the spirit world and the two may alternate in the successive human incarnations to which an individual is subject. It has been noted that, among Edo, good fortune is likely to be explained with reference to the head or the hand, matters for personal self-satisfaction, while ill fortune is attributed to one's *ehi* and therefore set beyond one's control. Legend recounts that, in return for board and lodging in the spirit world, the *ehi* has to pay with the back of its head. It is noteworthy that the so-called Udo heads (Fig. 20) and others shown on ritual regalia have precisely this area missing, suggesting that they are images not of the living or the dead but of the *ehi.*

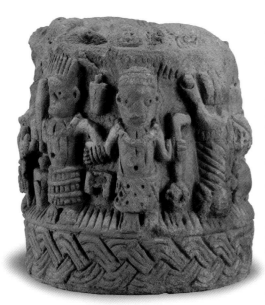

THIS PIECE is an example of the Benin hierarchy of materials, the 'same' object being produced in a number of media with minimal adaptation to the raw material involved. Standard Benin motifs are called into service, as in the brass versions, but are more grossly executed, with a loss of fine detail. It is likely that this piece was made for a brass caster, whose 'hand' would be particularly highly regarded.

FIGURE 19 *Altar of the hand. Terracotta, 19th century. H. 23 cm, W. 22 cm, D. 22.8 cm*

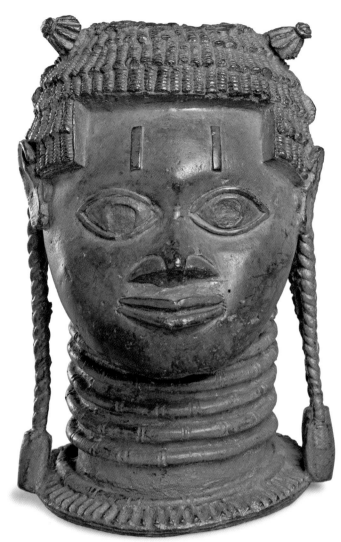

HEADS OF THIS form are usually associated with the town of Udo, located some twenty miles from Benin City. Brass casting is said to have begun there as part of a dynastic dispute in the sixteenth century between brothers, the making of one's own dynastic heads constituting a unilateral declaration of legal succession to the Obaship.

These heads were always assumed by earlier scholars to represent a female figure, but a careful examination of male head-dresses and coiffures suggests that this is not the case. The heads are unusually thick and clumsy for this early date, which may be a confirmation of provincial origins, but they also have a flared base, which is usually a mark of heads of much later origin. Typically they have a square aperture at the back of the neck, suggesting that they may represent an oba's *ehi*, or spiritual counterpart, since tradition records that this part of the head is payable for board and lodging in the spirit world.

FIGURE 20 *Head of an oba. Cast brass, ?16th century. H. 24 cm, W. 25.5 cm, D. 27.5 cm*

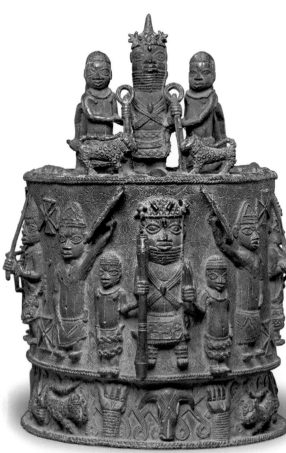

THE CULT OF the hand is widespread in southern Nigeria and its shrines involve a number of elements: a stool-like form, horns, and an association with warfare and success. In Benin most shrines include both a central cylinder and a semicircular base on which it stands. It is not clear whether both elements are required for all brass altars. Usually a small tusk would rest on the top (see also Fig. 18).

The dominant figure is an oba, holding two ceremonial *eben* swords downwards, a gesture of greeting to the ancestors. The figures on either side are tentatively identified as Olukoton and Olukohi, two priests active in sacrifices to the oba's hand. Before them are two leopards, on either side of a hole in which offerings of kola nuts may be made, and in low relief two crocodiles, the creature held to be the most suitable sacrifice on such an altar.

The central section again focuses on the figure of the oba, holding an *ukhurhe* rattle staff and a stone axe-head, supported by two servants and protected from the sun by two shield-holders. Within the royal palace this was another prerogative of the oba. Other figures bear staffs and a blacksmith's hammer. At the rear is a Queen Mother in full regalia, indicating the mystical backing expected from a powerful mother for her son. The ground bears a four-leaf pattern familiar from the plaques. The base carries representations of various sacrificial animals, a locked chest (to signify wealth) and a palm-wine container on a decorated ground.

FIGURE 21 *Altar of the hand for an oba. Cast brass, late 18th century. H. 44.2 cm, W. 33 cm, D. 35 cm*

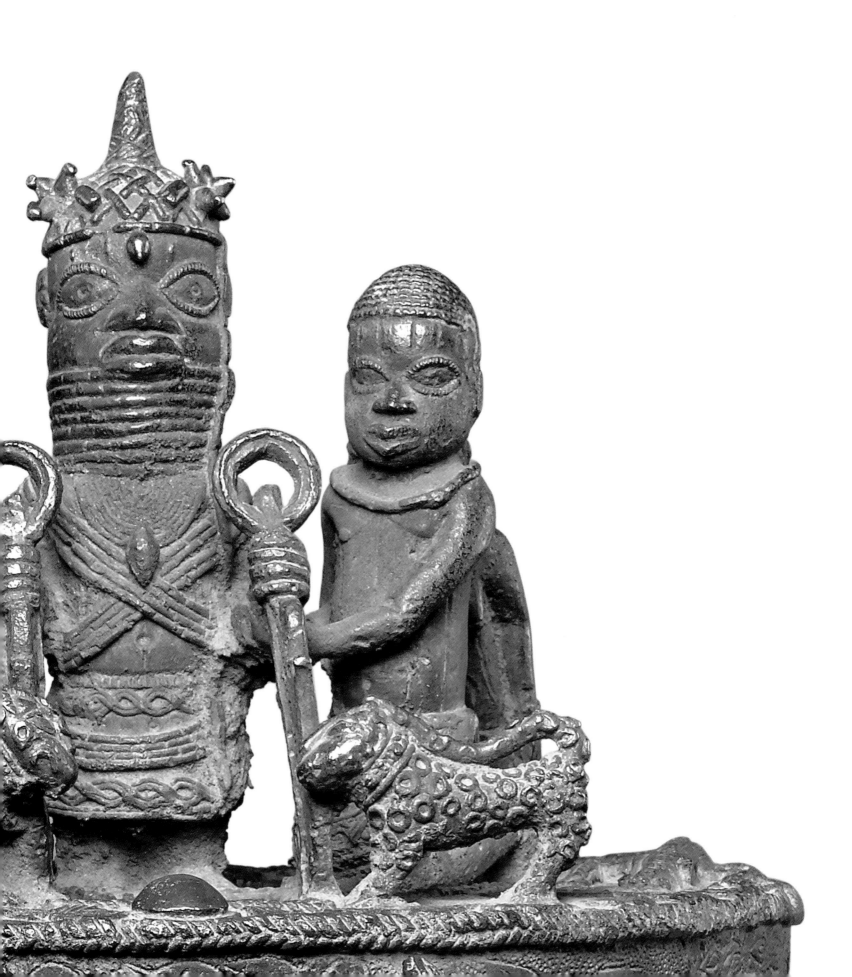

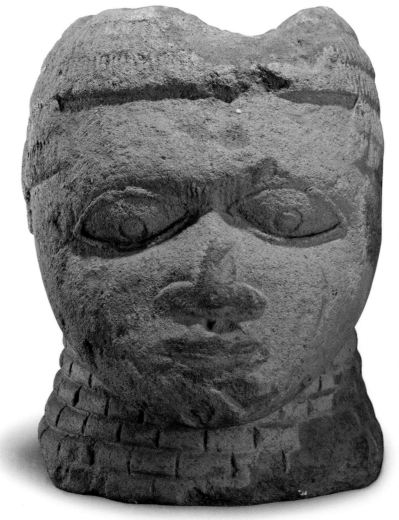

ALTHOUGH MADE in terracotta, this head is very much in the style of the 'early' or 'trophy' bronze heads (Fig. 23). While brass casters have terracotta heads on their ancestral altars, they are much more widespread outside Benin City. To some, this is evidence that they are associated with the Ogiso dynasty, which preceded the present line, to others that they are the mark of lesser members of the royal house sent out to provincial exile.

FIGURE 22 *Commemorative head. Terracotta, ?18th century. H. 20.4 cm, W. 17 cm, D. 20.2 cm*

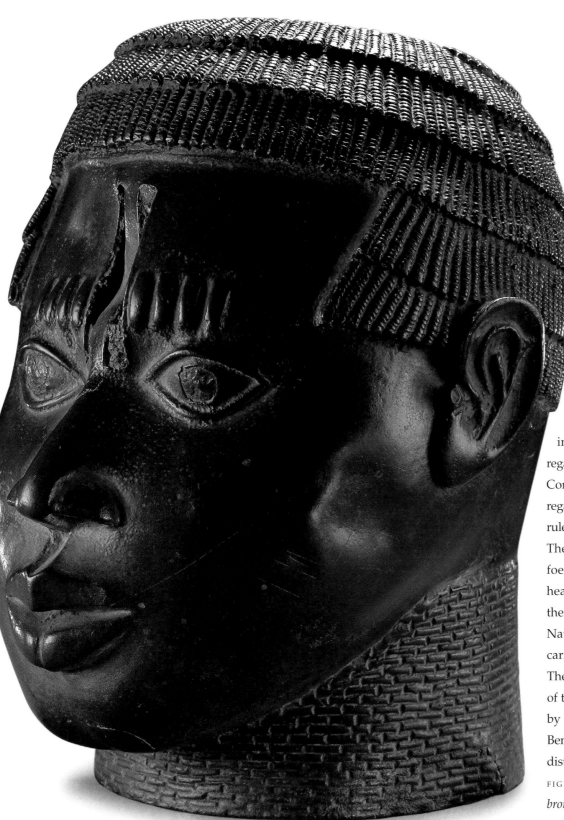

METAL ANALYSIS, style and the extreme thinness of the casting argue for assigning an early date to this work. The eyes and scarification on the forehead are marked with inlaid iron strips, which have corroded away. The high collar represents coral beads, but the coral cap worn by obas is absent. As in many African traditions of representation, Benin images always show a person in the prime of young adulthood, regardless of their true age and appearance. Contemporary informants in Benin City regard this as a 'trophy' head of a foreign ruler, rather than a representation of an oba. They recount that defeated recalcitrant foes would be decapitated and their heads cast in bronze to be placed on the shrine of the Ancestors of the Benin Nation. Certainly it could never have carried a heavy tusk like the larger heads. There is no doubt that the interpretation of these heads has been greatly confused by the publication of pictures taken of Benin in 1897, after the altars had been disturbed (see Fig. 15).

FIGURE 23 *An 'early' or 'trophy' head. Leaded bronze and iron, 15th century. H. 21 cm*

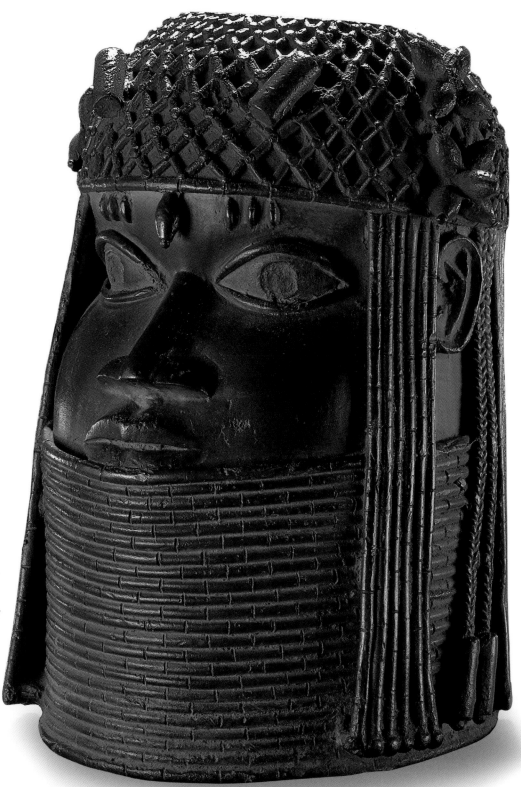

THIS HEAD would conventionally
be assigned to the period between 1550
and 1650, which is also the favoured
date for the casting of the brass plaques.
It is intermediate in type between the
extremely heavy works of the nineteenth
century and the very thin castings of the
earliest heads. In style, too, it is relatively
restrained, showing the coral regalia of
the oba without the marked elongation
of the neck or the decorated flanged
bottom of later pieces.

FIGURE 24 *Commemorative head of
an oba. Cast brass, 16th–17th century.
H. 27.7 cm, W. 20 cm, D. 22.5 cm*

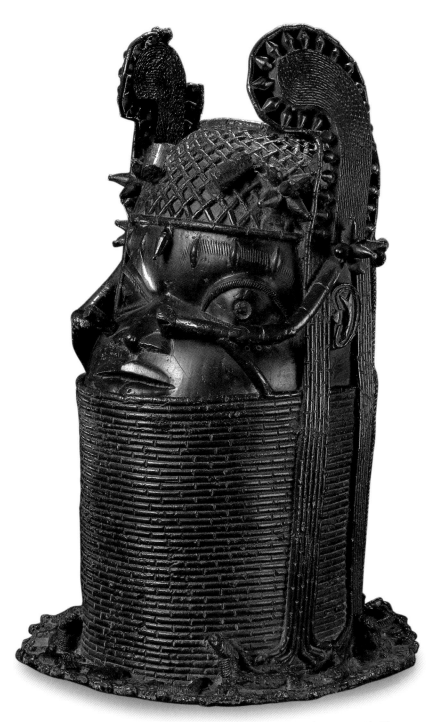

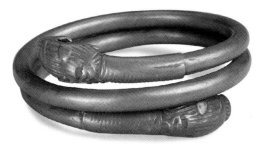

ARMLETS LIKE this were worn by chiefs and priests on the upper arm. Some contemporary informants link them with the sixteenth-century Oba Ehengbuda, who was noted for his herbalist powers. Occasionally they would be boiled in infusions of leaves and medicine to enhance their special powers. A multitude of different forms of bracelet and armlet can be seen worn by the figures in the brass plaques. The inclusion of human heads is not unusual, and these show the facial scarification usually interpreted as belonging to 'foreigners'.

FIGURE 25 *Twisted armlet. Copper and brass, 18th century. H. 3.5 cm, diam. 9.3 cm*

THE MASSIVE weight and broad base of late heads such as this offered a solid support for the heavy carved tusks that rested on them. The complicated winged headdress and cap represent the ritual dress of the oba, composed of red coral beads, which is worn on important ceremonial occasions (see Fig. 57). The eyes are inlaid with iron. Images around the base show leopards, stone axe-heads and other royal and ancestral motifs.

FIGURE 26 *Commemorative head of an oba. Brass, late 19th century. H. 53 cm, W. 33.5 cm, D. 35 cm*

KINGSHIP

Made from royal materials, displayed in the palace and featuring depictions of the ruler, Benin art is essentially one long discourse on the nature of kingship. Some writers have claimed to find an evolution in the notion of Benin Obaship through history. The earlier period, up to 1650, typically has its trophy heads and plaques showing scenes of warfare, with warrior obas inflicting defeat on foreign enemies or strutting ceremonially within the city. It is concerned with martial virtues, a proud hierarchy of death-dealing and expansion of the state through battle. The end of the seventeenth century ushered in a period of crisis in kingship, with civil war, rebellious chiefs and disputed succession, until the restored obas of the eighteenth century – now sequestered in the royal city – institute large statuary, carved tusks and complex altarpieces. This sees a change in the focus of art, which concentrates on the legitimacy of succession as its theme through the

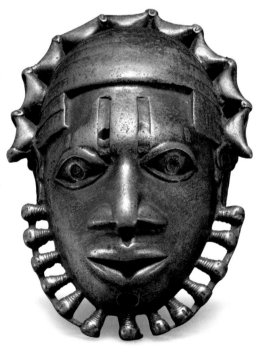

This mask in the form of a human face is pierced at the chin to allow the attachment of a cloth streamer and bell. It would have been worn at the hip where the cloth is tied (see Fig. 30). The eyes and forehead scar are marked by inlaid strips of iron that have rusted away. The strong modelling follows the iconography of the 'trophy' heads and so it may represent a foreign victim rather than the oba, more commonly depicted on hip masks. A pierced fringe around the crown is finely counterbalanced by a radiating beard of false bells around the chin, and the surface is unusually yellow in appearance and very worn, possibly from polishing.

FIGURE 27 *Hip mask. Cast brass, 17th century. H. 17.5 cm, W. 12 cm, D. 5 cm*

THIS PHOTOGRAPH of Oba Akenzua II at a reception with the British governor of Nigeria in 1936 shows two different idioms of power. The oba and other chiefs are wrapped in great swathes of cloth below the waist to exaggerate their bulk. The British governor wears a tight uniform, built-up shoes and a hat with a high plume to exaggerate his height and is preceded by a high staff.

FIGURE 28

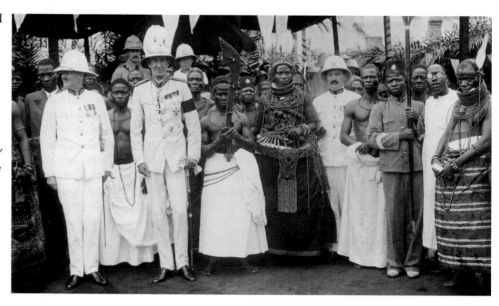

elaboration of the royal altars. The dark side of kingship is also developed, with images of human sacrifice and occult power that can either protect or destroy. Henceforth the Benin kingship rested on two pillars: display and fear.

Regardless, the art of Benin continues to reflect recurrent rites rather than unique events. Kingship remains a device which converts the linear time of history into the circular time of ritual. The primary distinguishing power of the oba is his monopoly on the right to take human life: of slaves or prisoners of war, but also of rebellious chiefs. Dress and regalia stress the parallels between the oba, as ruler of the land, and his aquatic counterpart Olokun, ruler of the sea, in a complementary relationship of armed rivalry.

The Benin kingship locates its roots in Oranmiyan, a prince of the neighbouring Yoruba people. It is ironic that the foreign origin of the dynasty was central to its historical legitimacy, leading in turn to a constant stressing of the distinction between village and city within the Edo kingdom. The Yoruba element in Benin may have been expected to vary, being either stressed or muted according to circumstances, just as other peoples of the Niger Delta, more recently, maintained or denied an ancestral link with the Benin kingship itself during the shifting fortunes of the Biafran war.

Edo rulers exploited idioms of power on all channels, in art and in their public authority over life and death; in loud noise, constant attendance, bright royal materials, lavish dress and bulk: 'big men' were expected to be physically large (Fig. 28). Through their elaborate dress and accoutrements, the oba and his courtiers were transformed into walking works of art. Yet attempts to explain Benin art always forget the most important point about power in the wider empire: it was not the display of the oba that was terrifying, but rather his complete invisibility at the heart of a sealed palace.

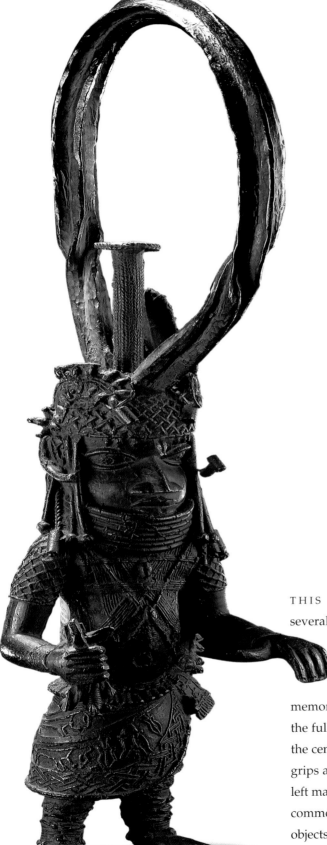

THIS CURIOUS PIECE is one of several of similar design. It shows an oba in full bead regalia and wearing the winged headdress that is depicted on the later memorial heads (see Fig. 26). He wears the full bead collar and a large bead in the centre of his chest. The right hand grips an *eben* ceremonial sword and the left makes a gesture with thumb extended, common on shrines of the hand and other objects. It seems likely, from comparable pieces, that a spike may have extended from the bottom of the dress, to be driven into the ground. This would be the natural extension of the rod rising from the centre of his head. Most striking of all is the attachment of a twisted metal loop to the head, the same as is found on an *eben* sword, which has sparked several imaginative suggestions as to its function, none entirely convincing.

FIGURE 29 *Figure of an oba. Cast brass, 19th century. H. 57.4 cm, W. 14 cm, D. 22.2 cm*

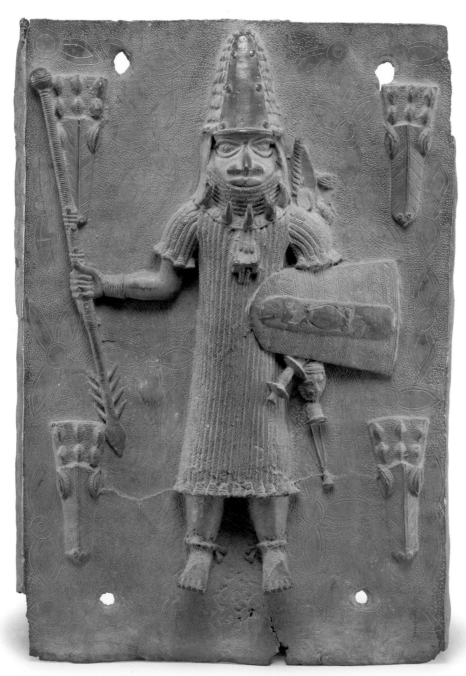

THIS FIGURE'S NECKLET of leopard's teeth and a bell indicates that he is a warrior. Nowadays the long coat seen here and on other plaques is interpreted as chainmail. The hem and sleeves are fringed with bells. The most famous figure connected with chainmail is Oba Ozolua (*c.* 1480–1504). The spear is barbed, and was probably used for fishing. At his hip he wears a small mask similar to that in Fig. 27, with streamers and bells attached. A sword handle appears from under the shield and his coat seems to be teased up into the high 'tail' seen elsewhere on the plaques. In the corners are heads of crocodiles, messengers of Olokun. They are depicted in the same way that such creatures appear on brass masks hung from the belt, so probably indicate not actual animals but rather pieces of regalia. Some time after his deposition, Oba Ovonramwen was asked about this figure by a German trader and replied that it showed 'a rich man'.

FIGURE 30 *Plaque showing a warrior. Cast brass, 1550–1650. H. 46.2 cm, W. 33 cm, D. 7 cm*

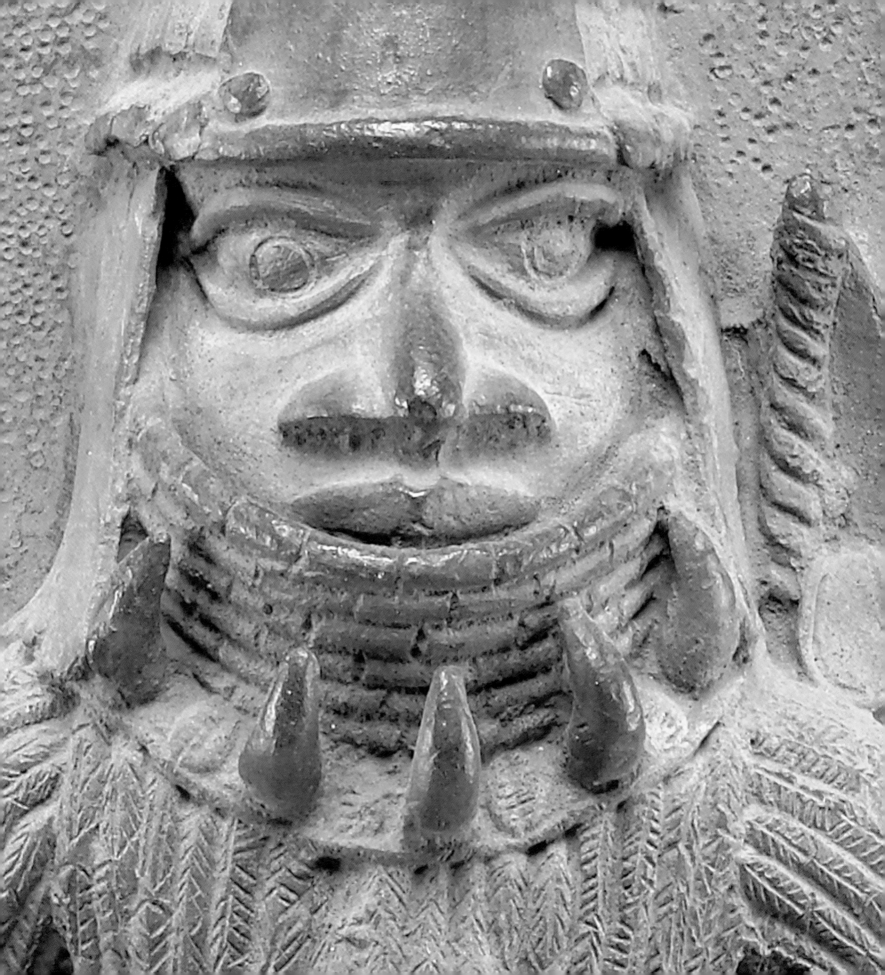

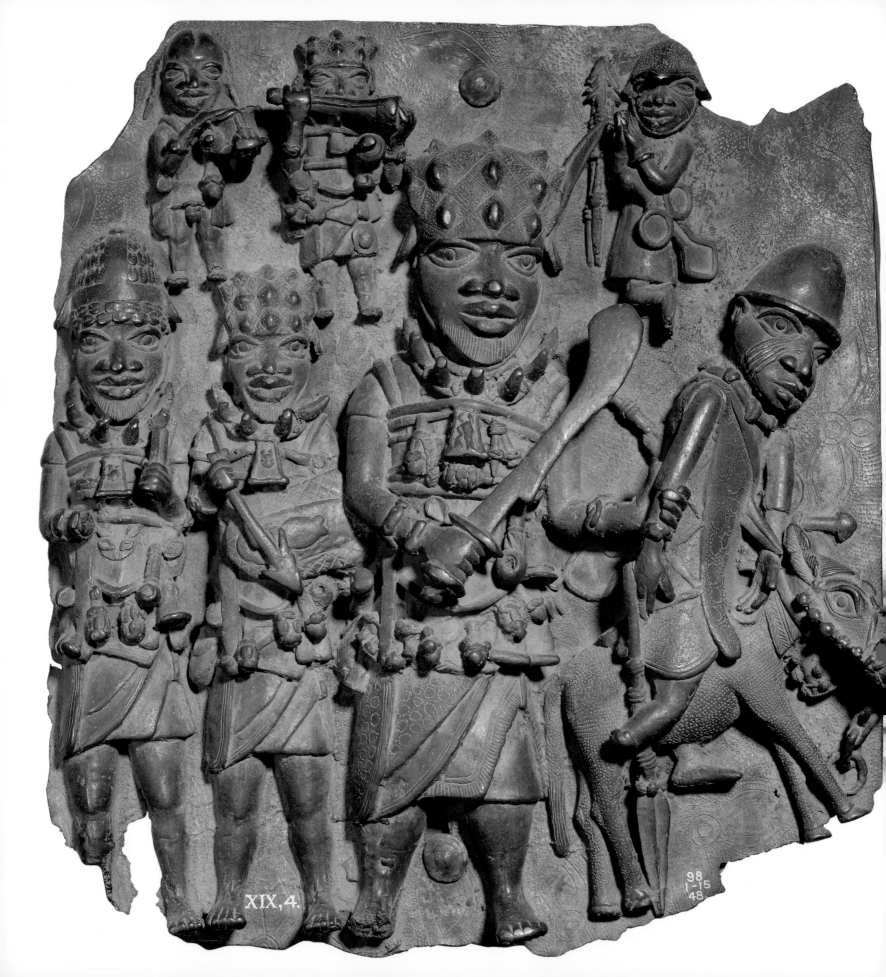

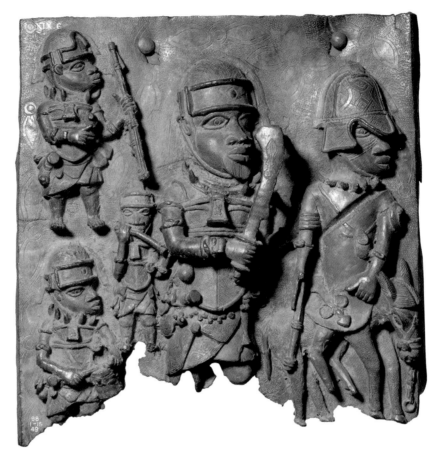

THIS IS ONE OF the richest of the
Benin plaques, and technically one of the
most complex. The centre is dominated
by a large Edo figure with a sword.
At this date there is no reason why this
should not be an oba, personally leading
his army; it may show Oba Esigie or
could be purely generic. He is followed
by smaller figures in Benin battledress
with helmets of cowries or crocodile hide,
along with even smaller musicians. He
grasps a wounded mounted figure with
'foreign' facial scarification, twisted into
an awkward profile that contrasts with
his own assured pose.

FIGURE 31, OPPOSITE *Plaque showing
a scene of battle. Cast brass, 1550–1650.
H. 43 cm, W. 40 cm, D. 7.5 cm*

IN MOST BENIN plaques (see Fig. 31)
the figures look squarely out at the viewer,
enhancing their posed and 'photographic'
quality. This plaque is different as the
warriors face to the right. The bottom of
the plaque is incomplete and the metal
seems not to have flowed properly into
this area, so that it is difficult to interpret
the right arm of the prisoner. Since he
already bears a deep gash across the
chest, this may have been deliberately
amputated in the original conception.

FIGURE 32, ABOVE *Plaque showing a
scene of battle. Cast brass, 1550–1650.
H. 40 cm, W. 40 cm, D. 9 cm*

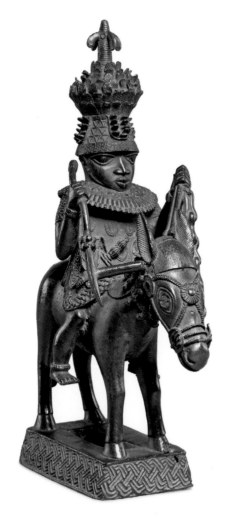

FIGURES LIKE this are known to have appeared on royal altars in the early nineteenth century, but who they represent has always been a matter of controversy. The rider wears a hat only seen on horsemen or plaques showing horsemen. The ornate dress, armour, bracelets, weapons and spurs are depicted in great detail. Even the bells around the spear brandished in the right hand are crisply modelled in what is technically a very complex casting. The horse is controlled with a single rein, without a bit, after the medieval Iberian fashion. Horses cannot thrive in the forest climate of Benin, and various traditions attribute their introduction to the Portuguese or the Yoruba. Unlike them, Benin forces never had a separate cavalry. It seems that horses were available to transport foreigners from the port of Ughoton to the capital in the seventeenth and eighteenth centuries. However, although Dapper confirmed that the oba rode horses on processions around the city, he rode side-saddle, a pose adopted by clearly Edo figures on some of the plaques (see Fig. 58). The cat's-whisker scarification suggests a foreigner but is also found on the crossbearer in Fig. 65. If this horseman is accepted as Yoruba, this strengthens such an identity for the crossbearer. A slight complication is that the unusual and impressive hat has been reintroduced into Benin at least once, having been seen by an Edo chief in a London exhibition where this work was displayed.

FIGURE 33 *Figure of a horseman. Cast brass, 1550–1650. H. 48 cm, W. 15 cm, D. 31 cm*

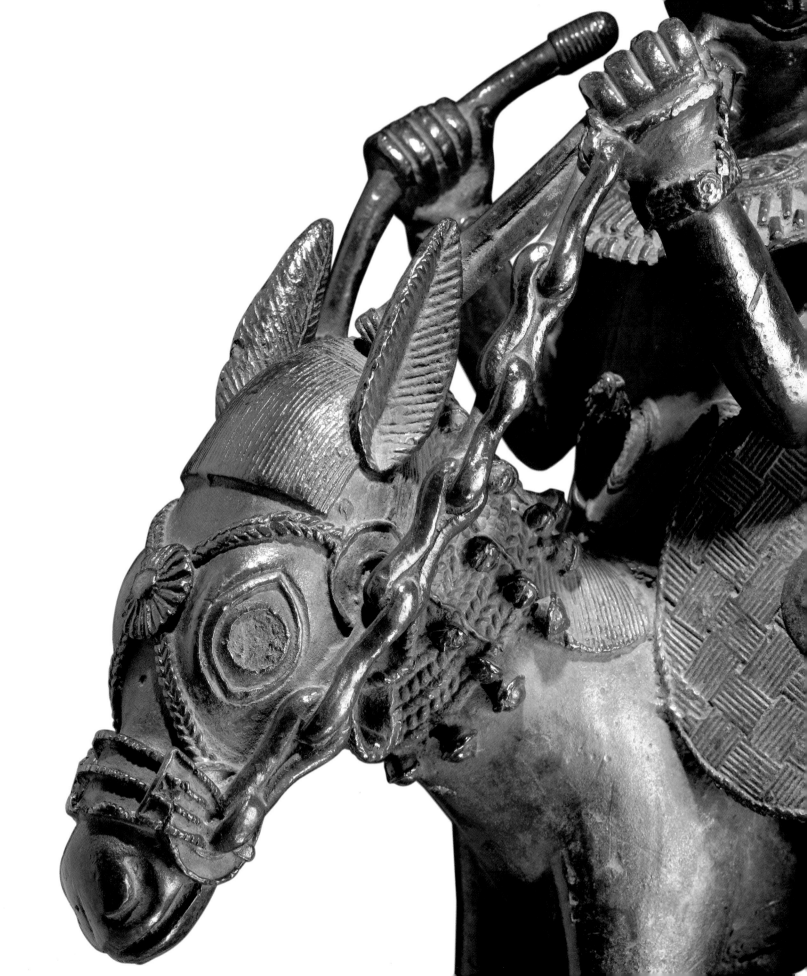

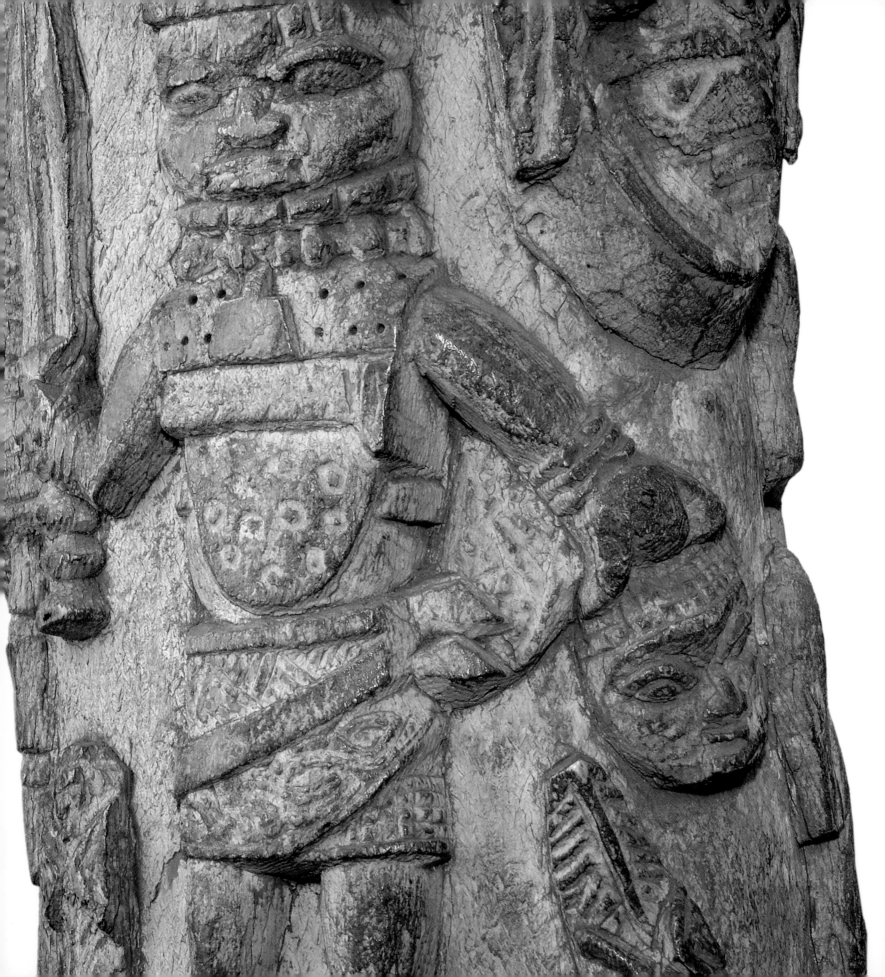

SINCE THE FIRST Benin carved tusks arrived in Western collections, attempts have been made to 'read' them. The 130 or so tusks in the classic corpus have been collected into groups on the basis of motifs, style and condition, the assumption being that this yields sets that would have stood together on a single altar. A complicating factor is that tusks were burnt in the fire of 1897, and that ivory is anyway a sensitive and non-durable material when exposed to weathering, so that altar installations cannot have been stable over time.

By such criteria, this tusk would be considered to date from the eighteenth century, its designs being based largely on those of the plaques. The surface is worn and friable, bearing traces of the red earth of Benin, and the base is broken. Motifs are arranged in vertical bands and particular significance is attached to the figure grasping a head (shown in the detail)

as indicating that this tusk was made for the formidable *ezomo* or war leader Ehenua, who saved the kingship from rebel chiefs. Other motifs on other tusks are similarly 'read' as being the mark of particular obas. Despite the formidable detective work on which such assumptions are based, it remains the case that all Benin decorated objects draw on much the same pool of motifs, swiftly reduced to a few stereotyped arrangements and with only minimal regard to local appropriateness.

FIGURE 34 *Carved tusk. Ivory, 18th century. L. 232 cm, W. 12 cm, D. 14 cm*

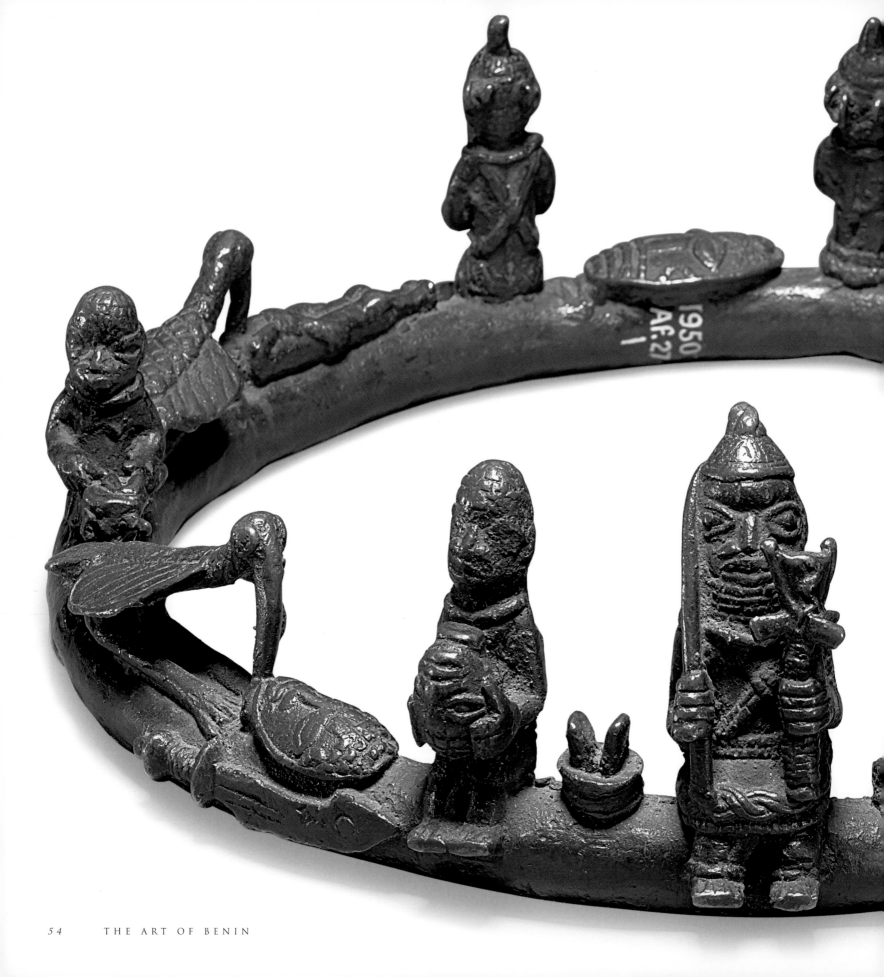

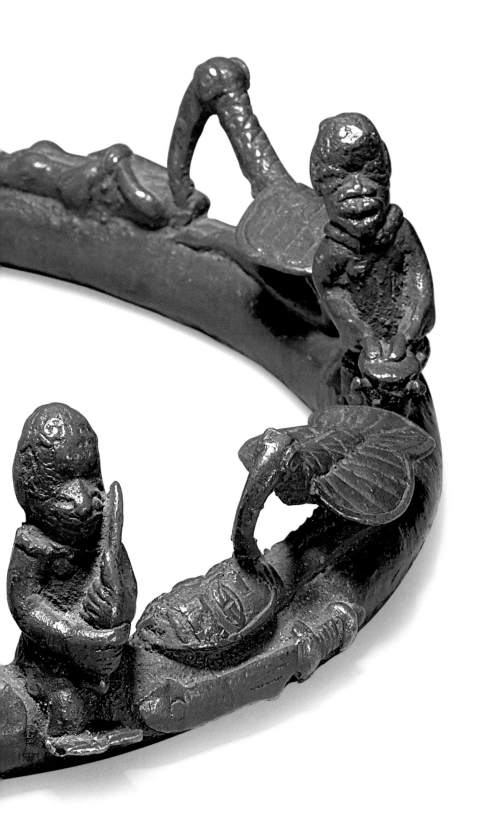

AT THE FRONT of this ring sits an oba in full regalia. He holds in his right hand a wand and in his left a ritual mace, the *isevbere igho*. On his right are two stone axes, on his left a box containing power-giving medicines. The figure to his right holds a human head, that to his left a gourd bottle of palm wine. Elsewhere vultures pick at human corpses and heads. Sacrificial victims were despatched in this fashion, their arms pinioned behind their backs and a stick thrust between their teeth as a gag from fear of the power of a dying man's words. The killing of vultures was forbidden in Benin and their consumption of a victim was read as a sign that an offering had been accepted.

FIGURE 35 *Ring showing scenes of human sacrifice. Cast brass, 18th century. H. 9 cm, diam. 26.5 cm*

THESE EXTRAORDINARY bracelets
are each made of two interpenetrating
cylinders of ivory, carved with consummate
skill. The outer bands are dominated by
carved oba figures in bead regalia. In
their hands they swing crocodiles, finely
figured and inlaid with studs of copper.
The oba's legs transform into mudfish
and his penis into a crocodile head with
a hand at the end of its jaws. The inner
cylinder is carved with a fine fretwork
of ivory bearing twin elephant heads,
similarly inlaid with copper and alternating
with the oba figures between which they
project. The trunks of the elephants also
end in grasping hands, holding serpents.
Ivory cuffs are always worn with the
oba's bead regalia.

FIGURE 36 *Pair of matching bracelets. Ivory,
inlaid with copper, 18th century. Diam. 10.5 cm*

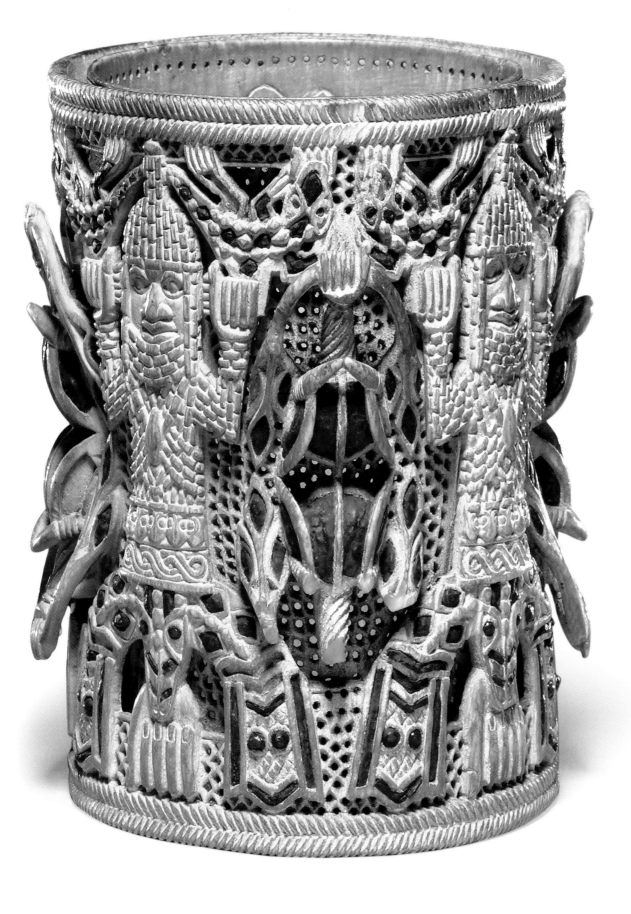

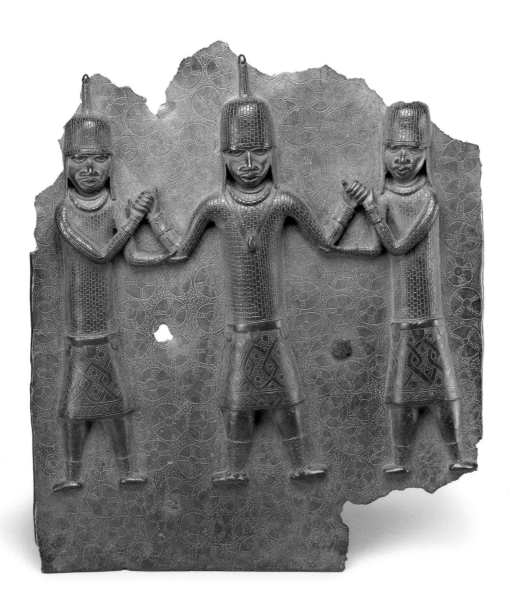

THIS UNUSUAL PLAQUE is one of a small group attributable to a single hand on the grounds of style and the use of the circled cross motif as background decoration. It has been suggested that they are the earliest plaques but evidence for this is lacking. Stylistically the caster is distinguished by his elongation and rounding of the human form, which sets him off clearly from other artists.

The central figure is an oba in bead regalia. Folklore stresses the enormous weight of the bead costume and headgear. This is both factually correct and a convenient symbol for the burdens of divine kingship, which must be distributed to be bearable. Foreign visitors recount that the oba would be eased of the weight of the beadwork by retainers at regular intervals even when seated in state. At ceremonies he is supported on either side by sturdy attendants, as here. Around his neck he wears a large agate bead, the *ivie egbo*, credited with enormous amuletic power.

Fragments of iron nails remain fixed in the plaque, having been hammered through the surface to fix it in position. The missing parts were smashed when it was torn down, clearly with great violence.

FIGURE 37 *Plaque showing an oba supported by two attendants. Cast brass, 1550–1650. H. 42 cm, W. 37 cm, D. 3.5 cm*

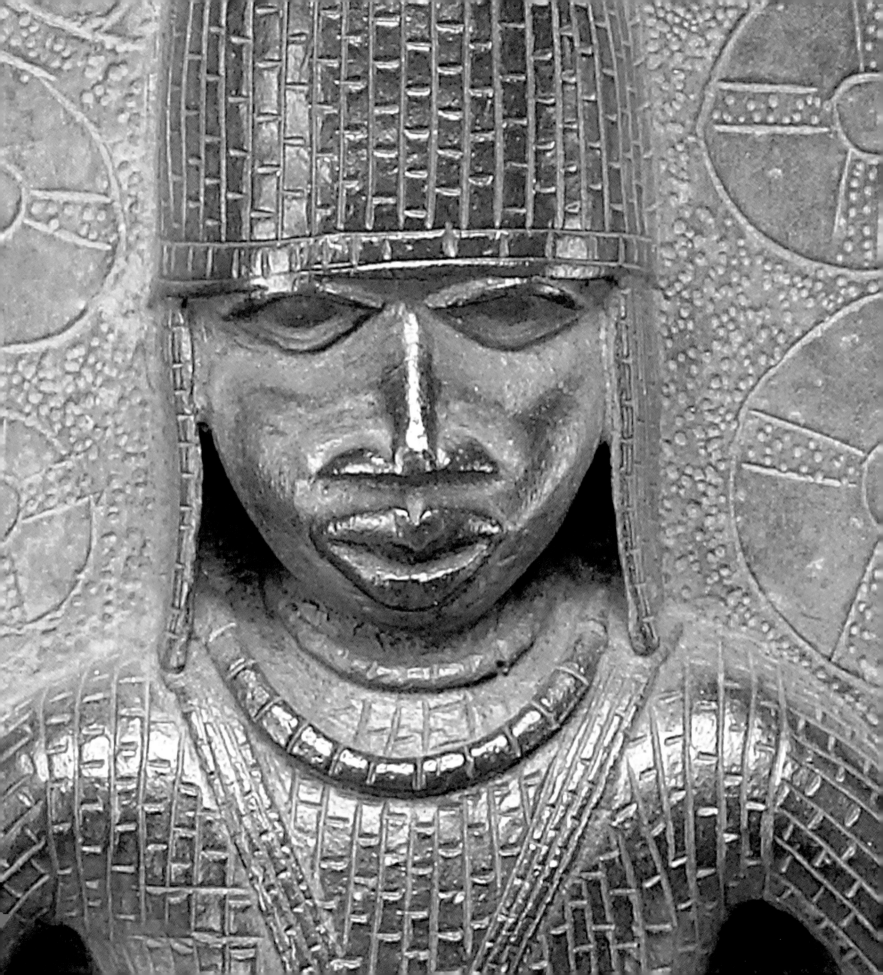

SWORDS OF THIS form were purely
ceremonial and had no cutting edge. They
were associated in legend with the ancient
Ogiso dynasty, which had been replaced
by the descendants of Oranmiyan. The
only time the two kinds of ceremonial
sword, *ada* and *eben* (see Fig. 46), appear
together is at the coronation of an oba.
The *ada* is said to represent the power to
take human life and was carried upright
before the oba by a page, or in front of an
important chief to whom such a power

might have been delegated. The blade is decorated with a brass leopard, lozenges and an incised motif of intertwined birds. Benin swords were sent to England by traders to be copied or plated by British craftsmen to provide gifts for the king. Shortly before the punitive expedition, the trader Cyril Punch had one copied by Mappin and Webb for Oba Ovonramwen.

FIGURE 38, TOP *Ceremonial* ada *sword with European blade. ?Brass, 19th century. L. 92.7 cm, W. 16.8 cm, D. 7 cm*

THE BLADE OF this sword is decorated with brass leopards and etched with flower-like motifs. The pommel is carved in the form of Portuguese Janus-heads, whose hats cleverly echo the disc that normally ends the grip of a Benin sword, like Fig. 38. The presence of ivory inlaid with coral beads confirms that this sword was made for the oba himself.

FIGURE 39, ABOVE AND RIGHT *Ceremonial* ada *sword. Iron, brass, ivory and coral, 18th century. L. 105.2 cm, W. 22 cm, D. 7 cm*

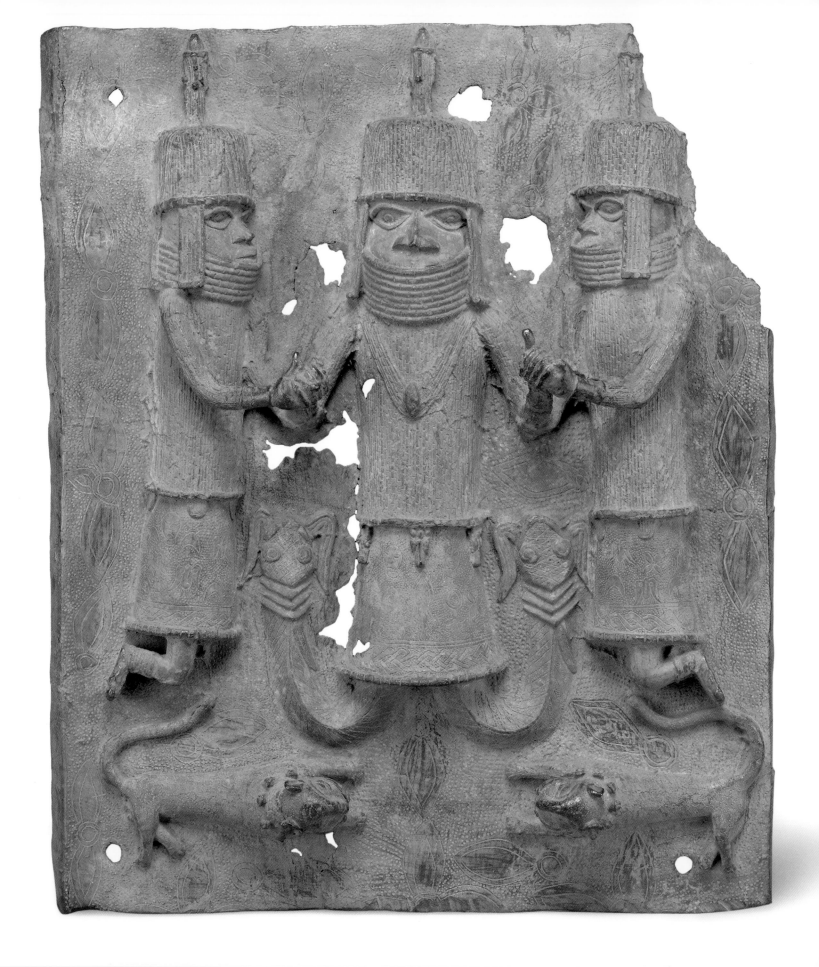

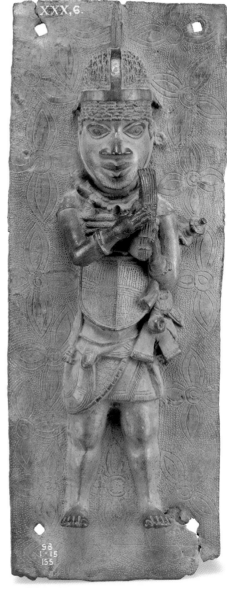

THE MOTIF OF an oba's legs being transformed into mudfish is very common in the Benin repertory. It may allude to Oba Ohen, who sought to conceal his crippled condition by claiming that such a mystical transformation had occurred. The oba is above concerns of the flesh, neither eating nor sleeping, yet is identified with the physical well-being of his whole people. Such an affliction would have severe metaphysical repercussions and be grounds for his removal. However, since the mudfish is a messenger of the sea-god Olokun, it may simply be yet another assertion of the parallels between the terrestrial oba and the aquatic god. This interpretation is strengthened by the presence of leopards, kings of the forest, at his feet and masks of crocodiles, also messengers of Olokun, hanging at his waist.

FIGURE 40, LEFT *Plaque showing an oba with his legs transformed into mudfish. Cast brass, 16th–17th century. H. 46.2 cm, W. 39 cm, D. 8.9 cm*

THIS PLAQUE SHOWS a warrior with leopard-tooth necklet and leopard hip mask. Unusually he has a small beard. On his head is a helmet of cowrie shells and he wears a breastplate of hippo hide. He is playing a thumb-piano with a gourd resonator.

FIGURE 41, ABOVE *Plaque showing a warrior. Cast brass, 1550–1650. H. 44.4 cm, W. 17.5 cm. D. 7 cm*

HORNS ABOUND in the art of Benin.
They are represented on plaques, tusks
and free-standing hornblower figures, and
were used at ceremonies, processions and
in the context of war. They vary greatly in
size but, regardless of length, they follow
a number of standard patterns. That on
the right is topped with an oba's head
and the interlaced pattern restricted to
royalty, unusual in openwork. Benin is
unique in Africa in that the mouthpieces
of its horns are always square and on the
outside of the curve. Below the aperture
a carved crocodile seizes a frog as its prey,
a common motif recalling Olokun. The
rim is finished with bands of geometric
motifs. The horn on the left is similar
except that it is tipped with a carved
hand. The same alternation between a
carved oba and a hand occurs on the
ends of *ukhurhe* rattle staffs, the hand
indicating nobility. The loops probably
would have carried small ivory bells.

FIGURE 42 *Two side-blown horns. Ivory,
19th century. H. 33.9 cm, W. 4 cm;
H. 27.5 cm, W. 4.5 cm*

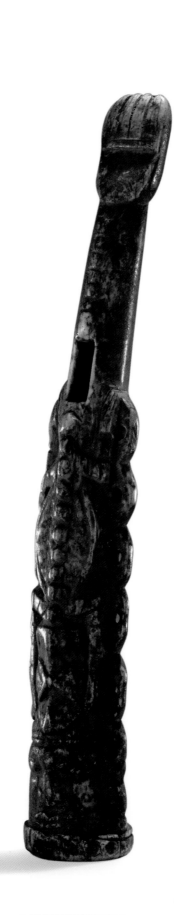
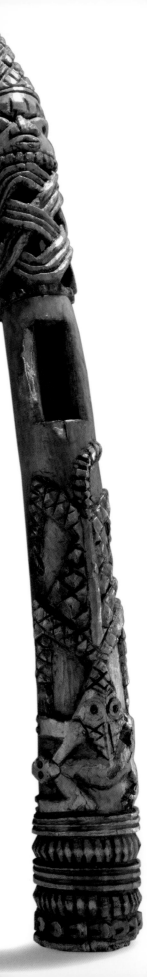

THIS BELL BEARS the face of a leopard and several forms of geometric marking common in the Benin corpus. Sections are divided by raised lines and separate faces are emphasized by cast plaitwork. Bells were important in Benin. Large ones like this were found in two main places. Several would be placed on ancestral altars where they were rung to draw attention to offerings. Alternatively they would be worn around the necks of warriors, together with a leopard-tooth necklet, or around the necks of their horses. Small bells (crotals) were imported into Benin from the West but also cast locally. They might be affixed to masks, anklets, containers and pieces of costume, and their jingling was a mark of status. A proverb warns young men that the most dangerous of sounds is that of the anklets worn by an oba's wives.

FIGURE 43 *Bell. Cast brass with iron clapper, 18th century. H. 21 cm, W. 11.2 cm, D. 12.4 cm*

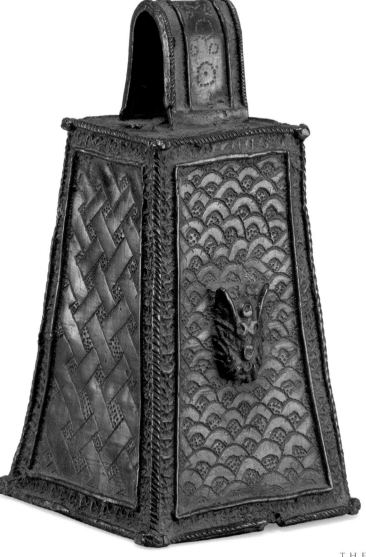

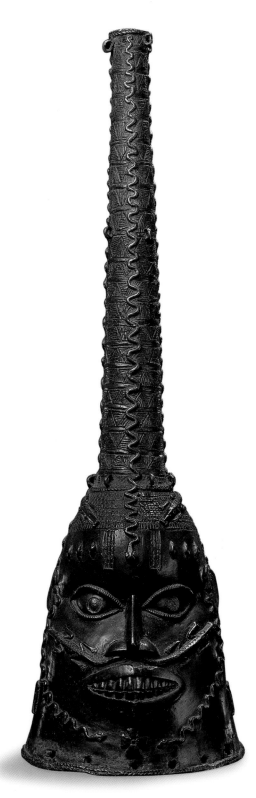

ORANMIYAN'S FATHER, Ododua, gives his name to a masquerade celebrating royal origins that is specific to Benin City and replaces the village Ovia cult masks, normally forbidden entry. This is one of seven 'characters' that perform together at the festival of Ague Osa, introduced in the eighteenth century by Oba Eresonyen as part of his stressing of the Yoruba origins of kingship. This particular mask represents Ora, the specialist in the magic of leaves, who accompanied Oranmiyan on his journey. It sits on top of the head with the wearer's face covered by a net attached to the holes in the bottom rim. The loops are for the fixing of leaves. In many ways it resembles masks from elsewhere in the Delta, the mouth particularly recalling Ijo styles. The snake running down the forehead echoes those on the turrets of the royal palace, while animals exiting the nostrils are a mark of the possession of exceptional supernatural powers as elsewhere in Benin and Yoruba art. The priests of Ora and Uwen, Osa and Osuan were greatly feared and seem to have deliberately cultivated such a reputation, engaging in the most bloodthirsty of Benin rituals, involving not only human death but – according to local tradition – cannibalism.

FIGURE 44 *Ododua mask with an extended projection. Brass, late 18th century. H. 69.6 cm, W. 22.5 cm, D. 23.4 cm*

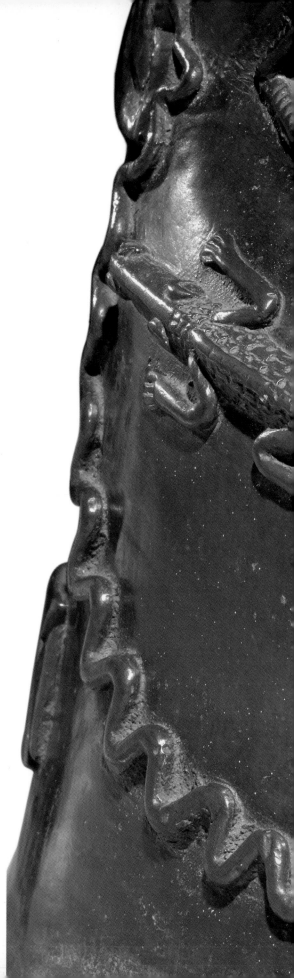

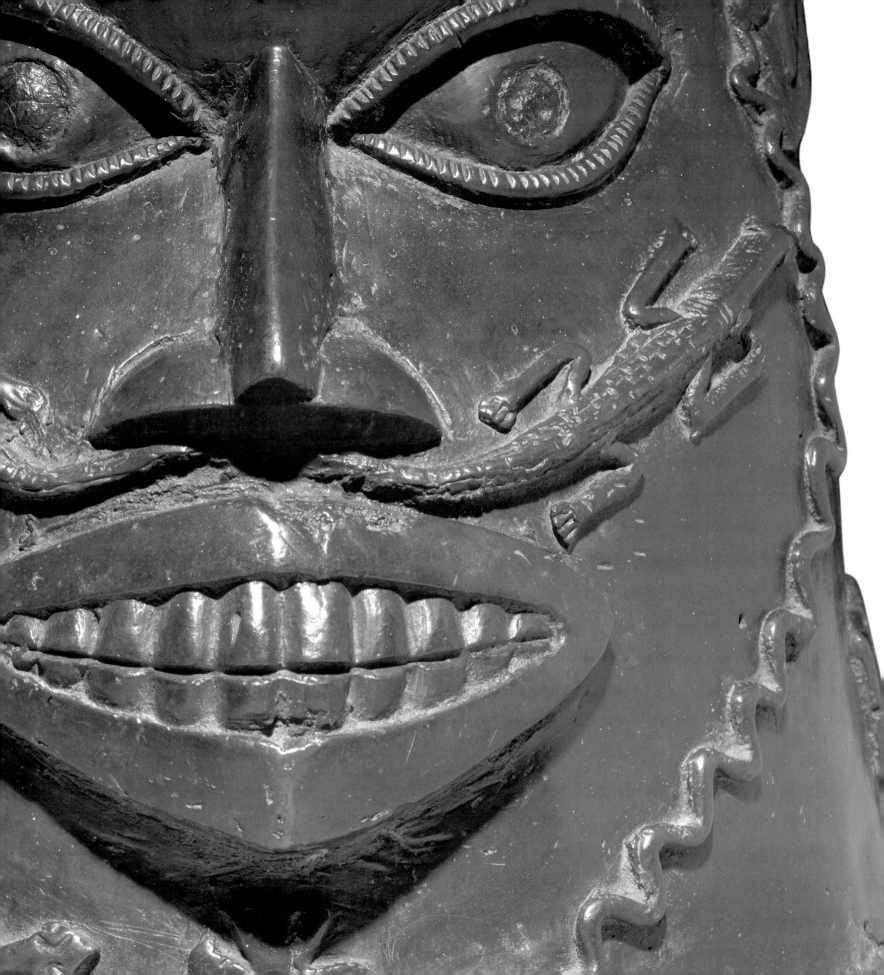

THIS PILLAR served as an armrest for the oba when seated in state in heavy regalia. Objects covered in hammered brass sheeting often use standard Benin designs scattered wholesale over the surface. This piece offers a tour de force of Benin geometric motifs of various origins. Many may be derived from chalked marks found in shrines to the god Olokun. The third and fourth bands from the top show the most attenuated form of 'Portuguese heads', also found in the centre of the top. The technique of brass repoussé work (hammered from behind) was probably imported from across the Sahara and may have been flourishing at the end of the nineteenth century, triggered by the supply of large amounts of Muntz metal by a British trader.

FIGURE 45, LEFT AND OPPOSITE

Pillar. Hammered brass, 19th century. H. 90 cm, diam. 34.8 cm

THIS IS AN *eben* sword, a large, flat object with a distinctive ring handle, which was carried by chiefs on ceremonial occasions and stored on the ancestral altars. The high point of the festival of Ugie Erha Oba is when the king, having been greeted by the leading chiefs with raised *eben*, himself dances with such a 'sword' and touches the altar with its point. Such objects were never used as weapons and had no cutting edge. Often they are decorated with piercings and openwork, as here. Occasionally, like the *ada* swords (Figs 38 and 39), they may incorporate European blades.

FIGURE 46, RIGHT Eben *sword. Iron, 19th century. L. 114.2 cm, W. 34.2 cm*

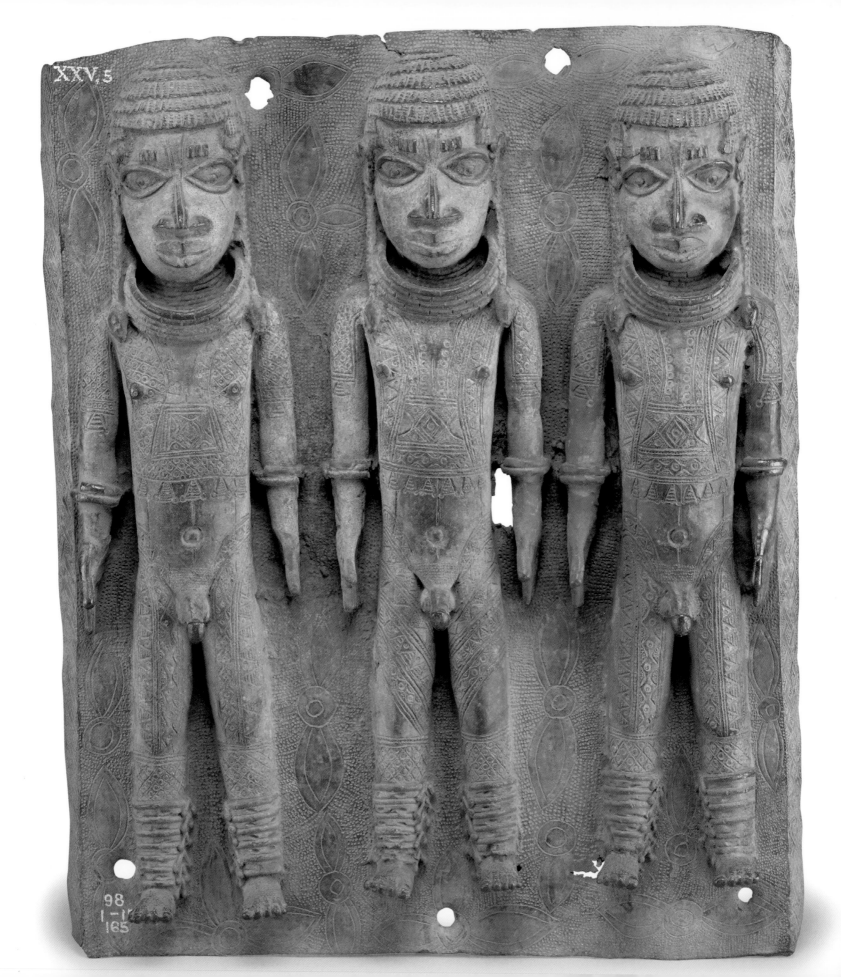

THE COURT

By the end of the nineteenth century, Benin City was home to about an eighth of the total inhabitants of the kingdom, itself estimated at some quarter of a million, and was encircled by a massive earth wall and ditch some six miles in circumference. The town was divided into two unequal parts by a broad highway which ran north-east to south-west. The southern part was reserved for the spacious and maze-like courtyards of the palace (Fig. 51) and the houses of the Palace Chiefs, the northern for the town, the Town Chiefs and the guild workers. Beyond the southern walls, but within an outer wall, dwelt the priests who cared for the dead rulers and the living oba's head, and the

PAGES SPORT much the same ornately layered hairstyles as the 'early' or 'trophy' heads. They are naked except for bracelets, anklets, necklets and the elaborate body paint that completely covers the torso, legs and upper arms. Within the palace this nudity expressed their contrast to the oba, himself extravagantly dressed. Theirs was a duty of constant attendance, assisting the oba and running errands outside the palace. At some point he would make them into men by giving them clothes, a wife and land.

FIGURE 47, OPPOSITE *Plaque showing three pages, emada. Cast brass, 1550–1650. H. 42.4 cm, W. 35 cm, D. 6 cm*

THIS PAGE, from an altar, bears an *eben* ceremonial sword in his right hand and in his left a bundle of spears, a specific ritual object intended to bring success in warfare.

FIGURE 48, RIGHT *Figure of a page. Cast brass, early 18th/19th century. H. 49.4 cm, W. 15.8 cm, D. 15.7 cm*

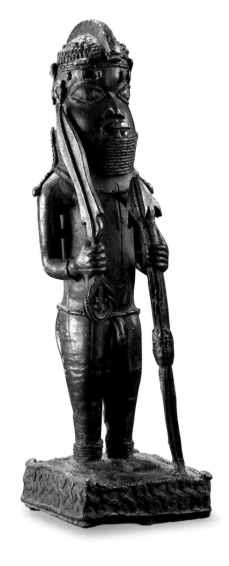

powerful *uzama* or 'kingmakers', who included the *ezomo* war leader. Beyond the second wall, the Crown Prince and the Queen Mother resided at the village of Uselu.

Neither the Town Chiefs nor the Palace Chiefs were strictly hereditary but were named by the oba. Whereas the Palace Chiefs might be expected to be implacably loyal to the ruler, the Town Chiefs would often openly oppose him, under their leader the *iyase* and in the name of the people. The *uzama* were reduced over time to a moral rather than a legal authority, and the absence of a standing army severely limited the *ezomo's* independence of action. Nevertheless, as Benin history shows, factions and alliances within the court organization, lending support to different candidates for the Obaship, could easily undermine national unity. It was essential that an oba keep them under his eye and under his control.

Within the palace, the oba was served by three associations that, theoretically, included all freeborn Edo. The Iwebo had charge of regalia, the Iwegua were responsible for servants and household officials, and the Ibiwe-Eruerie looked after the royal wives. A whole section of the palace was occupied by these associations which, with their own servants, doctors and officials, would run to several hundred persons. Apart from named officials, the most important attendants were the pages, *emada* (Figs 47 and 48). These were boys given to the oba by their fathers, his own sons being obliged to leave the palace at the same age, while an oba's daughters would usually be married off to the Town Chiefs. Allowed access to all areas, *emada* were able to perform discreet missions anonymously and circumvent the sometimes formidable barriers that prevented access to the monarch.

The palace was the focus of the city and the kingdom, the centre of secular and divine power and the site of frequent ceremonies and ritual performances organized on both a daily and annual basis. It was a charged ritual space with controlled access, meaning that the 'audience' for Benin art as a manifestation of royal power was always very small, reflecting the size of the Benin political class. Ceremonies involved music and dance, bells, rattles, horns and drums. As the palace acted as a centre for redistribution of tribute, there was a constant coming and going of raw materials and supplies, presents and offerings, all of which had to be within agreed parameters. The walls of the palace were grooved with parallel lines in a special pattern and, in places, polished so that visitors compared them to marble. The doors and roof beams of the royal apartments were covered in stamped brass sheeting and doorways surrounded by mirrors set into the walls. In contrast to the ostentatious nudity of the pages, a certain opulence of dress was cultivated at court with a careful layering of patterned textiles, reflected in the dress of the statuary and figures on the plaques. Benin was famous for its cloths, both of cotton and worked raffia, and from the mid-seventeenth century onwards they were the principal export, being traded by Europeans along the coast as far as the Gold Coast.

THE FIGURE AT the bottom is conventionally identified as the *iyase* chief by his distinctive hat. Staffs of this kind might be borne by officials sent by him to secure supplies or carry out orders in his role as representative of the people or as a war leader.

FIGURE 49 *Staff. Cast brass, 17th century. L. 65.3 cm, W. 3.4 cm, D. 2.3 cm*

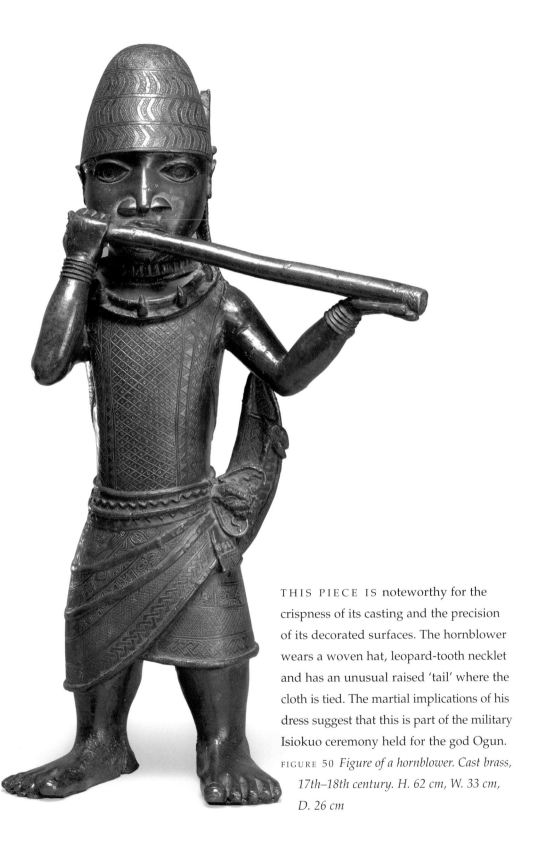

THIS PIECE IS noteworthy for the crispness of its casting and the precision of its decorated surfaces. The hornblower wears a woven hat, leopard-tooth necklet and has an unusual raised 'tail' where the cloth is tied. The martial implications of his dress suggest that this is part of the military Isiokuo ceremony held for the god Ogun.

FIGURE 50 *Figure of a hornblower. Cast brass, 17th–18th century. H. 62 cm, W. 33 cm, D. 26 cm*

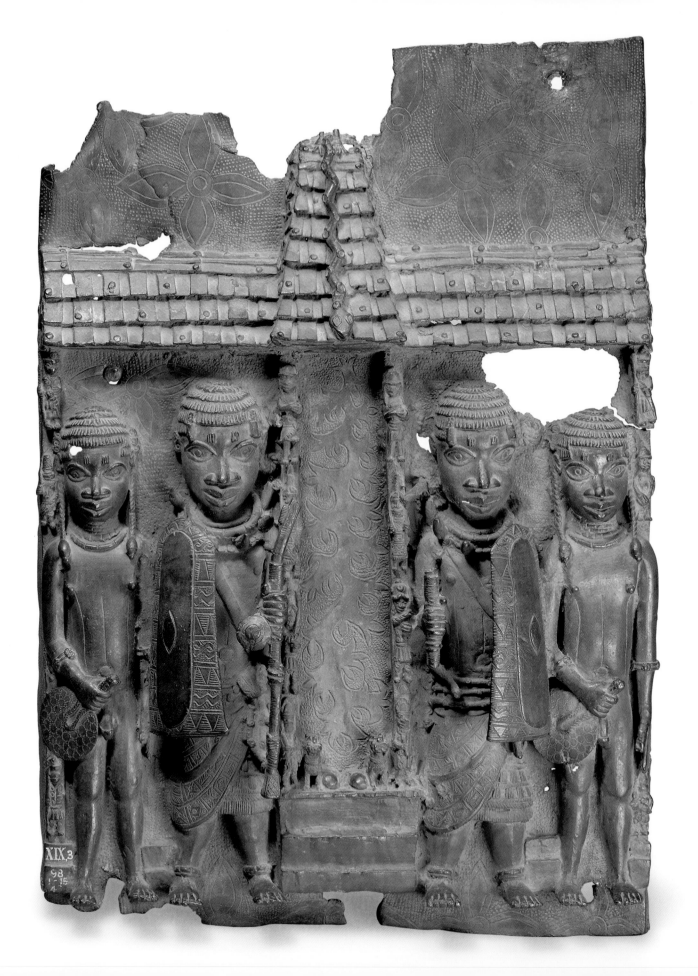

THIS IS THE 'KEY' Benin plaque, together with a comparable work in the Berlin Ethnologisches Museum. It shows other plaques in place in the royal palace, where they are used to cover the wooden beams that support the roof. They seem to have been cast in matching pairs. This piece has been much discussed and variously identified as showing either an altar or an entrance gate; the latter seems more likely. Pythons and turrets marked doorways giving access to the royal quarters, not altars. The background pattern between the central pillars differs from the four-leafed motif seen on the rest of this plaque and many others. Geometric patterns hammered into brass sheeting were photographed on the door to the king's apartments in 1897, so it is possible that this is what is depicted here.

The detail on the right shows that the plaque is so accurate that the individual plaques illustrated can still be identified: this is the one shown in Fig. 53. Three different arrangements of plaques appear in separate areas of this plaque and the one in Berlin, and, as far as they can be identified, the arrangements are purely arbitrary and not narrative, symmetry being the only requirement. The plaques have sometimes been seen as the result of European influence in the form of chapbook illustrations. This idea derives largely from the way they are normally displayed in Western museums, as individual objects. Seen in their original setting, they are simply a standard West African carved pillar cut into slices for ease of casting. Wooden pillars are only carved to be seen from one direction, so only one side would have been covered with brassware. They were affixed with iron nails driven straight through them and, when removed, roughly torn off and often broken, a further argument against the sacrality of Benin art.

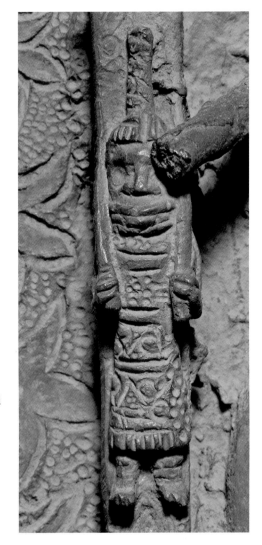

FIGURE 51, OPPOSITE, DETAILS RIGHT AND OVERLEAF *Plaque showing the royal palace. Cast brass, 1550–1650. H. 55 cm, W. 39 cm, D. 6.5 cm*

THE OBJECTS SHOWN on the steps
are the neolithic stone axes, still seen
at gateways to this day and considered
to be the material manifestations of
thunderbolts, together with two of the
leopard aquamanile (water jugs) with
which the oba washed his hands before
making offerings.

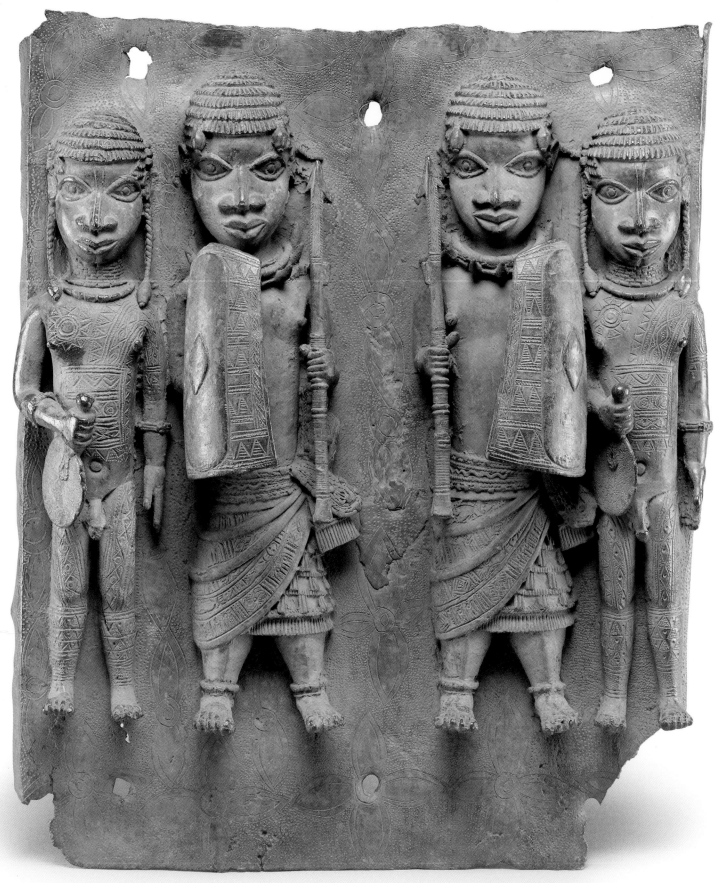

THE CHIEF INTEREST of this plaque
is that it is almost identical to Fig. 51, but
with the background omitted. Like all Benin
art, the plaques are strongly formulaic
and repetitive. The two outermost figures
are royal pages carrying fans, the two inner
figures bear shields and – on other plaques
where they are more clearly represented –
spears carried vertically instead of in the
more usual downward-stabbing pose. If
we accept the identification of the omitted
background as a gateway, these may be
images of the palace guard.

FIGURE 52, OPPOSITE *Plaque showing*
four figures. Cast brass, 1550–1650.
H. 47.7 cm, W. 39.3 cm, D. 10 cm

THE *OTON* WERE palace officials
who ceremonially beat the air with whips
at important ceremonies to drive away
evil forces. The bulge beneath the tunic is
made by the jawbones of a deceased senior
Town Chief. These were claimed by the
oba on their deaths as the instrument
they had used to argue with him in life
and so showed that he always had the
last word. Unusually, this plaque shows
clearly the scar that ran the length of
the nose of Benin males.

FIGURE 53, RIGHT *Plaque showing an*
oton *official. Cast brass, 1550–1650.*
H. 47.4 cm, W. 22.5 cm, D. 6 cm

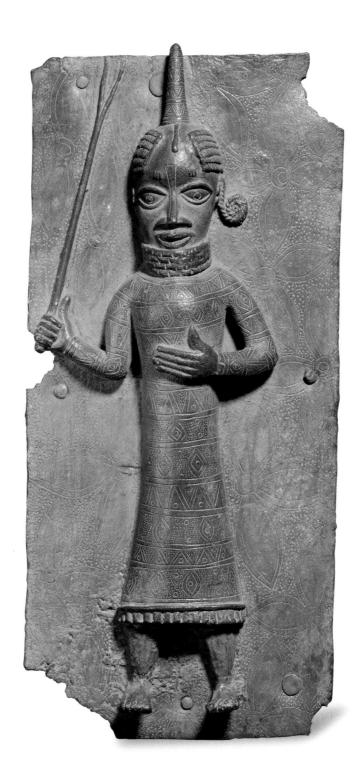

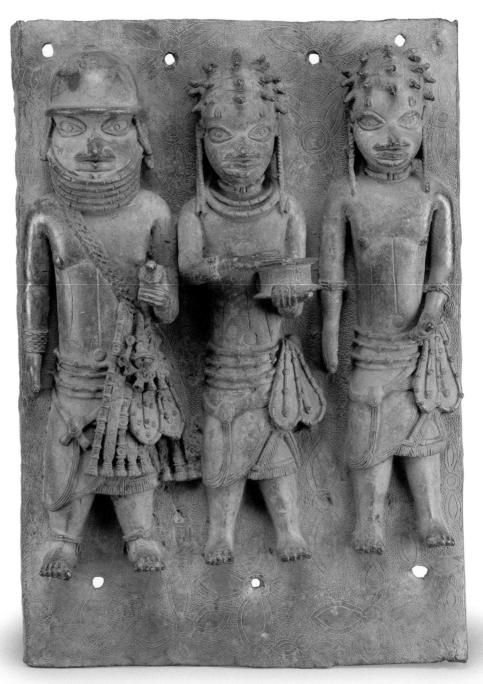

ON THE PLAQUES a number of figures are shown carrying boxes containing offerings. That held by the central figure is an *ekpokin*. It is made of two flanged intermeshing cylinders and may be constructed of various materials – bark, wood or brass – and may be covered with hide or leopard skin, which seems to be the case here. Several ceremonies involve the presentation of gifts to the oba and they would always be borne for a chief by attendants and be concealed in suitable containers.

FIGURE 54 *Plaque showing a chief and two attendants. Cast brass, 1550–1650. H. 55.5 cm, W. 36.8 cm, D. 11.4 cm*

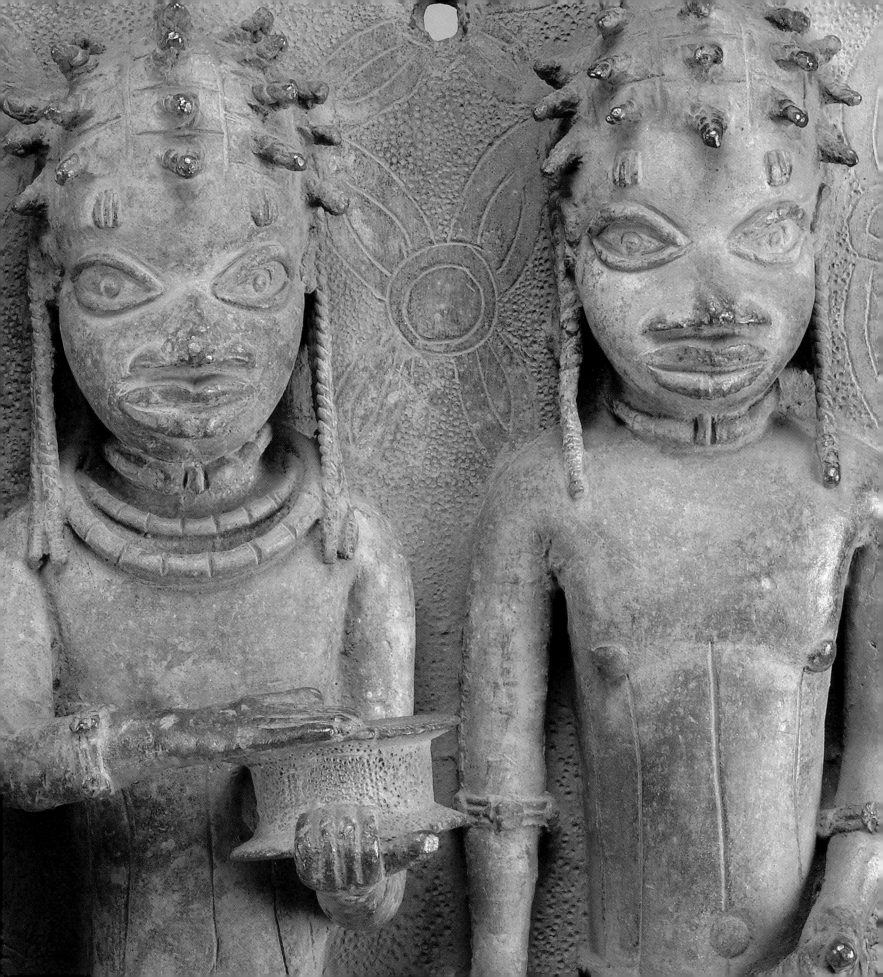

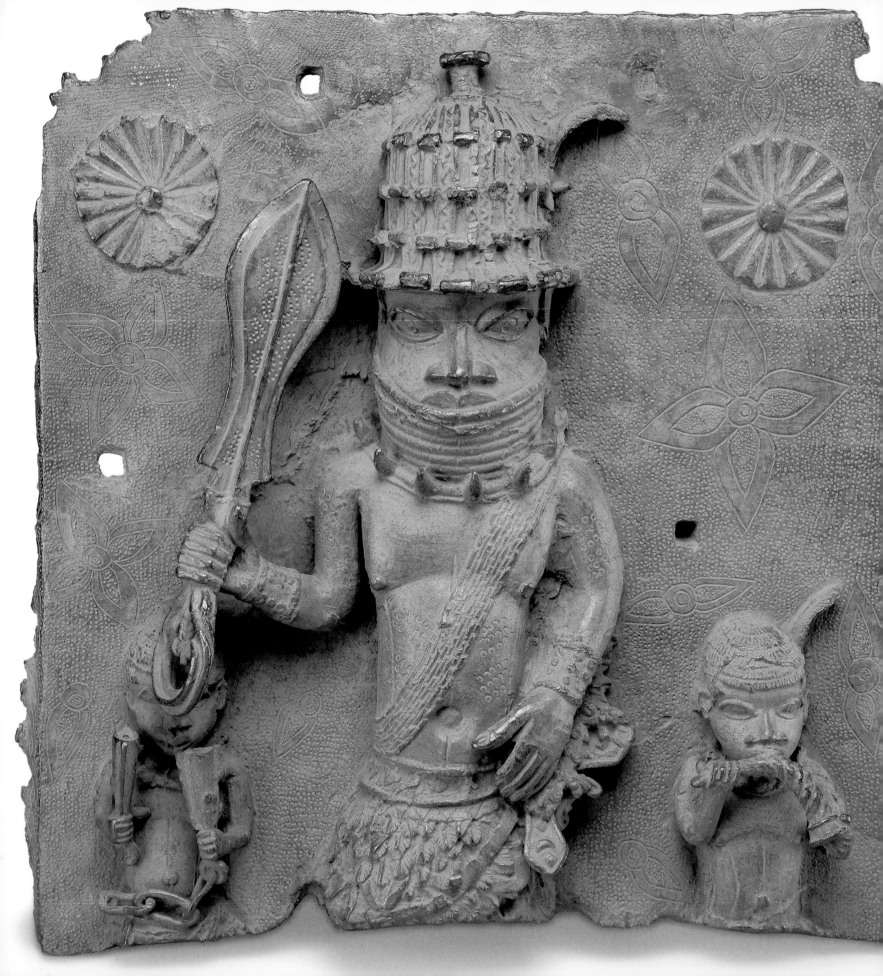

THE RITUAL YEAR

THE ROYAL YEAR IN BENIN IS PUNCTUATED BY A NUMBER OF FESTIVALS WHICH MUST SEEN AGAINST the backdrop of a complex and animated spiritual world (*erinmwin*) that constantly interacts with the material world of human concerns (*agbon*). These festivals and the objects involved in them form an important part of Benin religious life, for, apart from ancestral altars and altars of the head and hand, many Edo will have a special relationship with a particular god and may establish a personal altar through which this is maintained and strengthened.

Like many African creator gods, Osanabua, the high god, is seen as a somewhat remote figure, having withdrawn after the act of primordial world-making. While most acts of worship involve some token acknowledgement of him, his eldest son, Olokun, is more important in human affairs and of special concern to women as the source of children. Altars to him can be quite simple or of enormous complexity, comprising tableaux of many elaborate figures made of river mud, which recall scenes of chiefs, wives and servitors in the royal palace.

While white is the colour of Olokun and black of Ogiuwu, the bringer of death, red is the colour of Ogun, god of metal, and Osun, the healing power of leaves and herbs. Ogun is of interest to all who use or make metal tools and is to be recognized in the mud sculptures by his red eyes. Brass casters and carvers must make offerings to him on their metal tools to avoid injury and enjoy success in their undertakings. His festival, Isiokuo, involves processions of armed warriors through the streets and many of the plaques that are held to depict scenes of war may, in fact, show parts of this festival. Osun is the concern of medical specialists who fight against sickness, act against

THIS PLAQUE SHOWS the *iyase*, most powerful of the Town Chiefs, together with two musicians. The musicians are reduced in size, a form of 'social perspective' very common in Benin art, in which major figures appear larger than their social inferiors. He is identified by his distinctive hat with chiefly feather and the beaded sash that is a mark of eminence. Around the neck, he wears a beaded collar and a necklet of leopard's teeth. At the left hip, where his elaborate cloth is fastened, he wears a brass mask in the form of a leopard's head. The sword is the *eben* ceremonial sword with pierced decoration of the blade. This and the presence of musicians suggest a ritual rather than a martial context, possibly the festival of Ugie Erha Oba, which honoured the king's deceased father.

FIGURE 55 *Plaque. Cast brass, 1550–1650. H. 37.4 cm, W. 36.8 cm, D. 7.8 cm*

witchcraft and serve as diviners (Fig. 62). The powers of Osun specialists inhere in their iron staffs, the *osun ematon* (Fig. 63).

Royal rituals are either small and private, like that strengthening the oba's hand, or public, like that strengthening his head, involving resources from all over the kingdom. The ritual cycle has in recent years been greatly reduced and shrunk down to focus on the period around Christmas, but classically it was based on the agricultural year, opening with Ikhurhe to purify the land when the ground was cleared for agriculture in March. Next came the bead festival, Ugie Ivie, when the coral regalia of the oba was strengthened with an offering of human blood (nowadays that of a cow). At Ugie Oro, chiefs dance while beating the beak of a brass bird to commemorate the killing of the bird of prophecy (Figs 58–61). Eghute was performed against miscarriage and stillbirth, and against evil in general to protect the nine gates of the city. Ugie Erha Oba honours the king's father, and is followed by Igue. The former involves formal acts of submission by all chiefs to the ruler, the latter the important public strengthening of the oba's head. Here all the creatures of ritual importance within the kingdom – leopard, vulturine fish eagle, cattle, even elephant – were sacrificed to provide blood for the royal head. Then came Emobo, at which the oba used the new powers he had just acquired to strengthen the nation and drive away evil forces. This is followed by the Ogun festival for the god of metal and war, notable for its acrobats. The year closes with Ague, known throughout southern Nigeria as the New Yam Festival, and Ague Osa, which celebrates Ododua, father of Oranmiyan and founder of the royal dynasty (see Fig. 44).

THIS CONTAINER is identified as one used by the oba at Ugie Erha Oba, the ceremonial honouring of his ancestors. On the first day of the ceremony, it is brought to him by the messengers of the herbalists' guild and is filled with powerful magical medicines intended to assure his reign. Like many Benin ritual objects it is scattered with an assortment of standard royal motifs. The centre is a head, with usual Benin hairstyle, radiating serpents of power from its orifices, which divide the vessel into decorative sections. Further heads punctuate the surface and the familiar interlaced and four-leaf patterns provide a ground. Loops allow for the attachment of two styles of bells and closure is permitted by two sets of cast plugs on lid and base.

FIGURE 56 *Lidded container*, igie. *Cast brass, 19th century. H. 15 cm, diam. 18 cm*

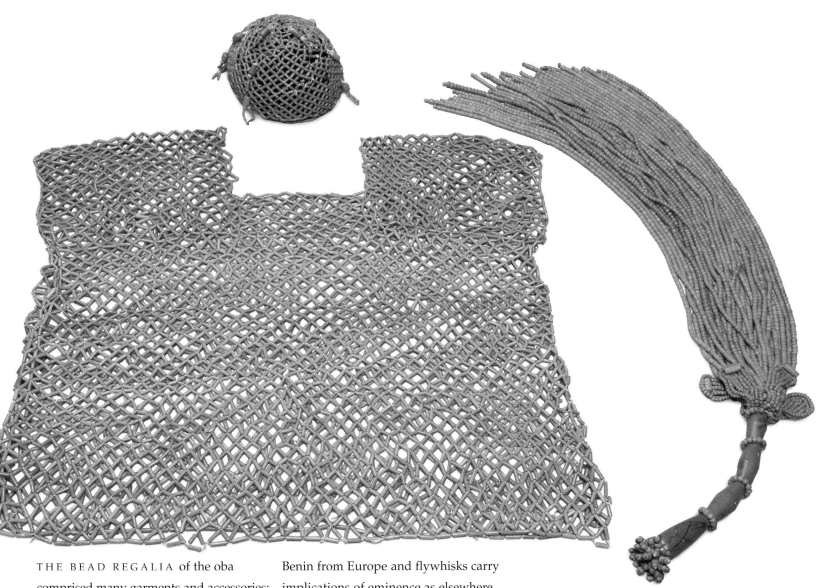

THE BEAD REGALIA of the oba comprised many garments and accessories: aprons, shirts, hats, necklaces and sashes. Such objects were intimately associated with the oba in his Olokun incarnation. Anecdotal histories tell of a man severely beaten in the streets of Benin City, even in recent years, for wearing a red string vest that too closely resembled royal dress. The cap is an attenuated form of a royal crown, which would be very much heavier. Horsetails were an early import into Benin from Europe and flywhisks carry implications of eminence as elsewhere in Africa. The strands of this piece are far too heavy for it ever to have been functional. It is another example of the Benin translation of objects from low into high materials to reflect the status of their owner.

FIGURE 57 *Corselet, cap and flywhisk.*
Coral and agate beads, 18th–19th century.
L. 71 cm, W. 65 cm; H. 10.5 cm, diam. 25 cm;
L. 101.2 cm, W. 7 cm, D. 7 cm

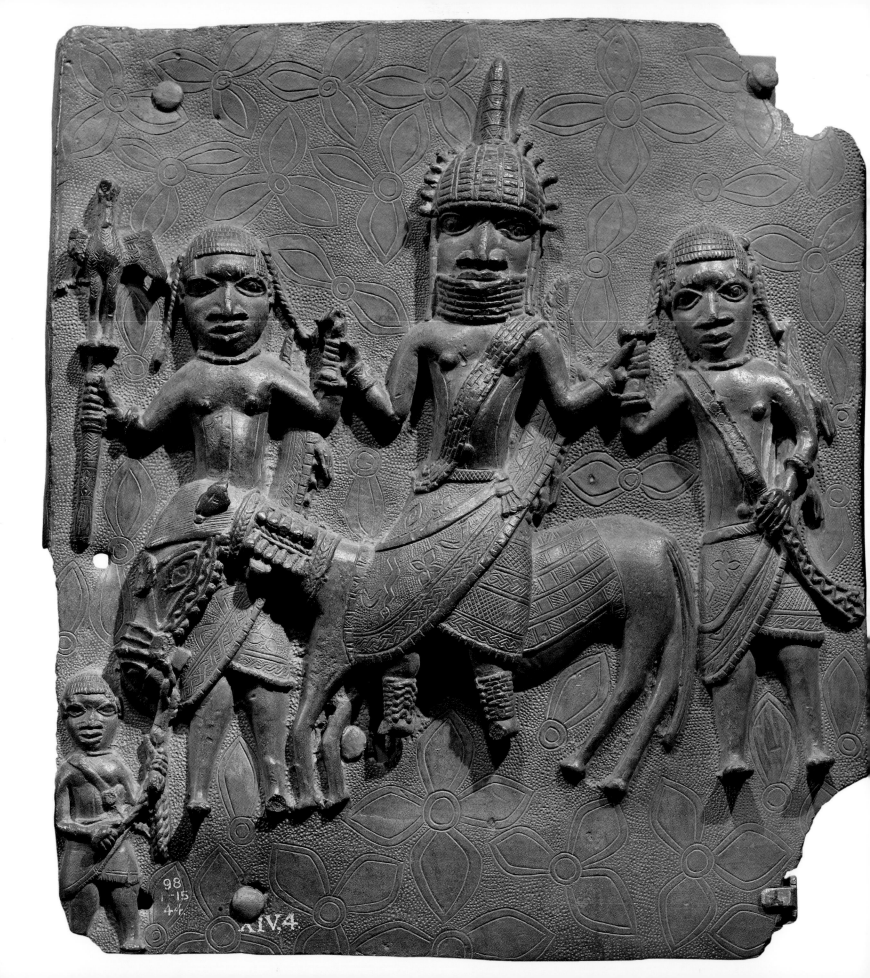

THIS PLAQUE SHOWS the oba in procession at the annual ceremony of Ugie Oro, which marked the victory of the oba over the bird of prophecy (see Figs 60 and 61) and shows his superiority to the normal forces that rule other men's lives. The treatment is very different to that of the plaque in Fig. 61, which depicts the same ceremony. At this time rulers still rode on horseback around the city, unlike in later times. The supporting figures, less ornately dressed, are probably pages. A mixture of perspectives is used. The side-saddle stance of the oba allows the horse to be presented in profile and the oba frontally, while the less important groom is deliberately diminished in size.

FIGURE 58 *Plaque showing a processing oba. Cast brass, 1550–1650. H. 38 cm, W. 43 cm, D. 4 cm*

THIS IS ANOTHER image of the *iyase*, most prominent of the Town Chiefs. The cylindrical base has been etched with geometric bands and flares to a line of interlaced pattern that is a standard design for the base of an object. The horseman is elongated, the horse diminished in size. Unusually for a clearly Edo individual, he rides astride his horse, not side-saddle. The carving is particularly firm and authoritative. While most chiefs at the Ugie Oro festival strike brass birds (Figs 60 and 61), a few prominent notables use ivory staffs of different forms, including the present design. They clearly appear as musical instruments on some of the plaques, though they have frequently been described in the past as flywhisk handles.

FIGURE 59 *Horseman staff. Carved ivory, 18th century. H. 40.8 cm, W. 7.4 cm, D. 7.8 cm*

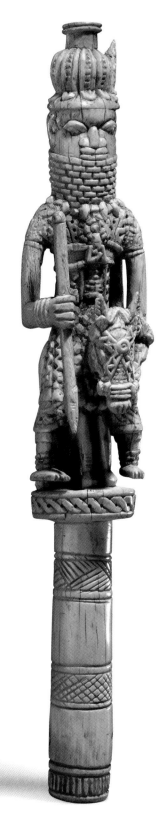

THIS MUSICAL instrument represents the 'bird of prophecy' (see Fig. 61). It would have been paraded and struck by chiefs at the annual ceremony of Ugie Oro to commemorate the Benin kingdom's military victories. The long, curved beak would have been beaten with a brass rod. All attempts to identify the bird, known simply as 'the bird of Oro', have failed, leading to the conclusion that it may well be wholly mythical. In its beak it carries a small object, interpreted as a medicine bundle.

FIGURE 60 *Bird idiophone, mounted on a cylindrical grip. Cast brass, 18th century. H. 32 cm*

THIS PLAQUE SHOWS senior chiefs, distinguished by feathers in their hair, at the Ugie Oro ceremony beating idiophones that represent the 'bird of prophecy' (see Fig. 60). The birds are associated with an incident in Oba Esigie's war against the Igala people in the sixteenth century. When Benin City itself was threatened, the oba led out a force against them but encountered the bird of prophecy, whose cries portend disaster. Defying the omens, he ordered that the bird be killed and enjoyed complete success in the campaign.

FIGURE 61 *Plaque showing three figures beating idiophones. Cast brass, 1550–1650. H. 46.5 cm, W. 37.5 cm, D. 11 cm*

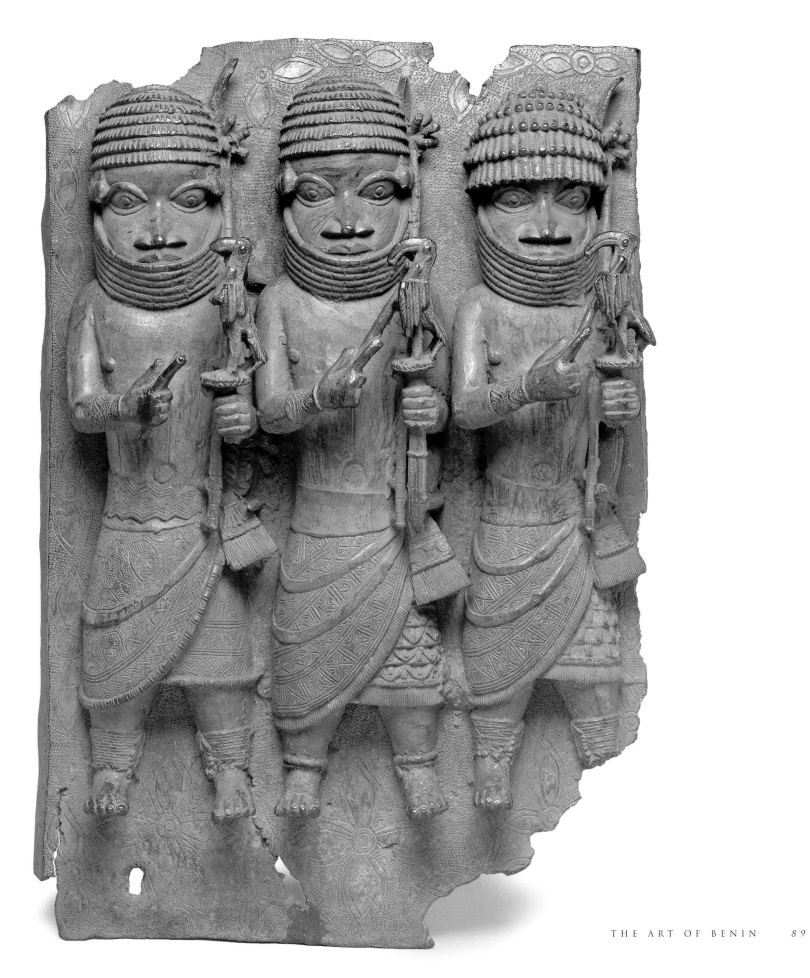

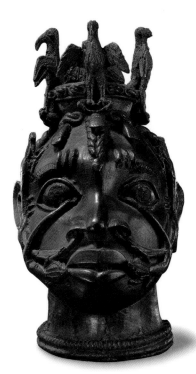

THE OSUN CULT was concerned with the magical powers inherent in medicinal plants and leaves. At the top of the head are grey herons, 'lords of the witches', possibly similar to those once on the palace roof, a reference to the anti-witchcraft powers of Osun diviners. Below are stone axe-heads, the thunderbolts hurled by Ogiuwu, bringer of death, and knotted manilla forms alluding to the binding power of spells. Serpents issue from the eyes, nose and ears, gripping frogs in their mouths and reflecting a traditional belief, according to which those with occult powers spout snakes from their bodily orifices. Snakes are the warriors of Osun or messengers of Olokun, according to species, and, like the grey herons, were also found on the palace roofs.

FIGURE 62 *Head of the Osun cult. Cast brass, 18th century. H. 27 cm, W. 14 cm, D. 17 cm*

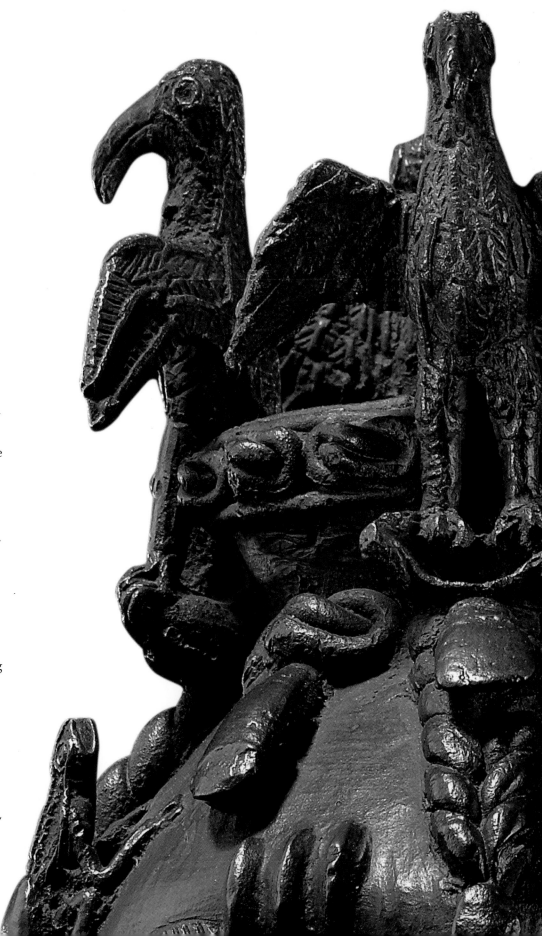

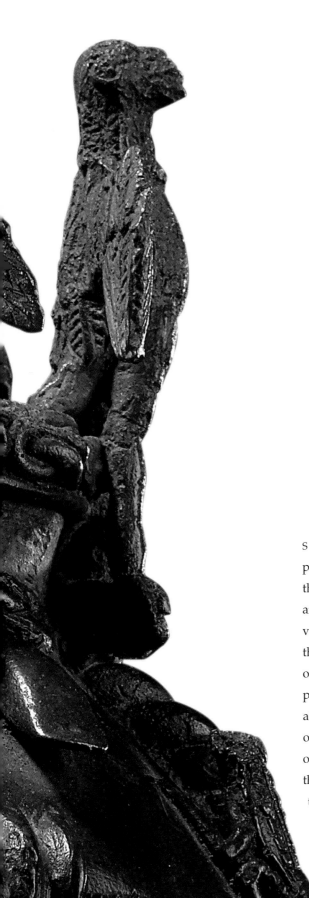

STAFFS OF THE OSUN cult, the power of the leaves and herbs of the wild, vary enormously in size and complexity. They occur in various contexts: stuck into the ground, placed on altars or carried as a focus of mystical power in war. Being made of iron, they also incorporate the power of Ogun, god of iron, and even brass versions are cast over an iron core. They are replete with the symbolism of animal powers. At the top is the 'lord of the witches' or – possibly – the vulture, surrounded by horns and other piercing, flame-like implements that have power against witchcraft. Clusters of gongs are set around the stem and at various points are chameleons, which in Benin, like elsewhere in Africa, are held to be poisonous and associated with the shape-changing ability of witches. Nowadays their skin is compared to the film of a camera that can be taken out at night and photograph witches to identify them.

FIGURE 63 *Staff of the medicinal cult of leaves*, osun ematon. *Cast iron, 19th century. L. 113.5 cm, W. 13.7 cm, D. 8 cm*

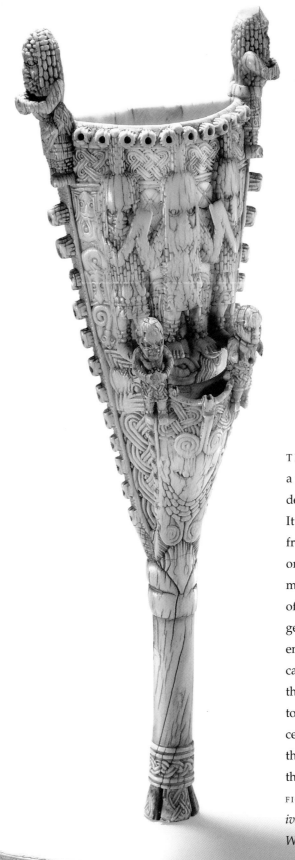

THIS IVORY GONG with a striker is
a tour de force of the ivory carver's art,
delicate, precise and exquisitely balanced.
It swarms with images of royal power,
from the oba in his Olokun incarnation
or in his beaded regalia to images of
mudfish, crocodiles and birds. Each
of the sounding vessels is rimmed with
geometric designs that attain a unique
energy, and the striker ends in delicately
carved mudfish that balance those of
the edges. An instrument very similar
to this is beaten by the oba at the Emobo
ceremony that banishes evil forces from
the city. Six of these survive, although
they may be greatly worn.

FIGURE 64 *Double gong and striker. Carved
ivory, 16th/17th century. L. 36.6 cm,
W. 12.8 cm, D. 8 cm; L. 28.4 cm, W. 1 cm*

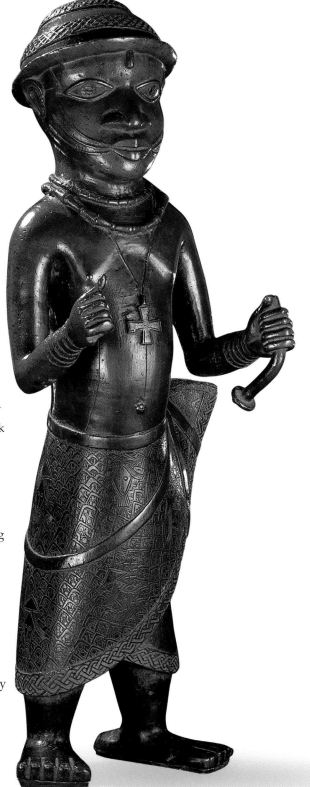

THE LEFT HAND of this figure should bear an L-shaped hammer (now broken), the right a staff (missing). Although he is represented in a number of media his meaning is unclear. When the Portuguese first arrived in Benin, they encountered crosses, which were important for their identification of the kingdom with that of Prester John. Afonso de Aveiro, who visited Benin in the 1480s (but was not published until the following century), recorded a tradition of a powerful inland monarch who was required to confirm each new oba on his succession and send him a brass hat, cross pendant and staff in token of his authority. In view of the traditional Yoruba origin of the present dynasty, scholars have been tempted to see this overlord as the ruler of Ife, which may have links with the introduction of royal brass casting in Benin. The 'cat's-whiskers' facial scarification seems to mark him as a foreigner, so this figure would then be the Oni of Ife's messenger.

Alternative traditions see him as an official of the Ewua, a priestly group within the palace in charge of a morning ritual recalling the oba's Yoruba origins, or as a priest of Osanabua, the creator god. Although the first clear evidence of the use of such figures on royal altars is an 1823 sketch – allegedly by Belzoni the Great, the famous archaeologist and circus strong man – the tradition is clearly considerably older.

FIGURE 65 *Large figure of a crossbearer. Cast brass, early 18th century. H. 63.2 cm, W. 22 cm, D. 7 cm*

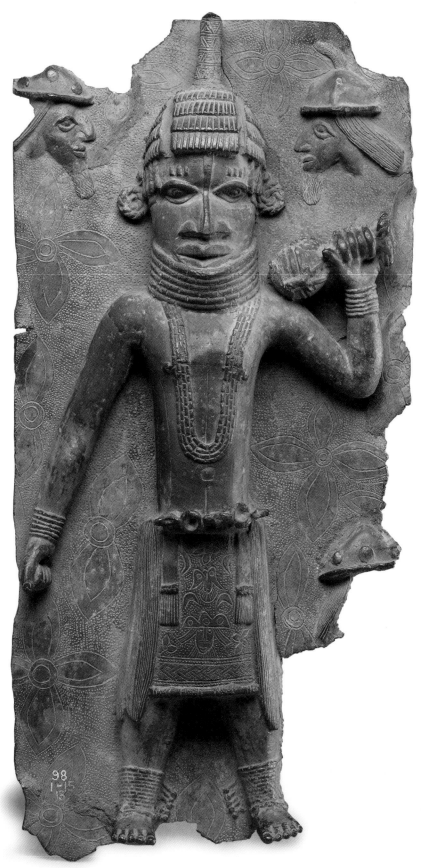

EMURU ARE MEMBERS of an ancient guild with special responsibilities within the palace. Legend has it that in the fifteenth century Oba Ewuare brought back coral regalia from Olokun's realm under the sea. He also brought magical brass vessels, *iru*, which could speak. The vessels were installed in the royal palace, cared for by *emuru*, and they pronounced on petitions made by subjects. Ewuare's heir, Oba Olua, was excessively curious and broke one of the vessels open to see just what it contained. He found nothing perceptible to mortal senses but the forces the *iru* housed departed and they never spoke again.

The *emuru* wears a special basketry hat with medicine under the protrusion. The *iru* rattle in his left hand terminates in a ram's head. One must be brought to be present at every sacrifice. The Portuguese heads in the corners are a link with Olokun and the trailing sashes at the waist are probably horsetails, an early export to Benin from the West.

FIGURE 66 *Plaque showing an* emuru *priest playing a rattle. Cast brass, 1550–1650. H. 40.6 cm, W. 20.2 cm, D. 5.2 cm*

ALTHOUGH USUALLY described as a
drummer, strictly speaking the instruments
played here are slit-gongs, made from
hollowed-out logs with no skin membrane.
The figure sits cross-legged and wears
a symbol in the middle of his forehead
which also features in the corners of
plaques. This is probably one of the
marks of Olokun that are written in chalk
around ritual spaces. It is customarily
interpreted as referring to the inevitability
of the sun's rising every day. In the upper
right are offering-boxes, one open to show
a mudfish. In the top left is a bundle of
yams, suggesting this performance may
be taking place at Ague, the New Yam
festival, which ends the ritual year. Its
unique colour is probably due to having
been cleaned and treated with neatsfoot
jelly while in a previous collection.

FIGURE 67 *Plaque showing a drummer.*
Cast brass, 1550–1650. H. 45.4 cm,
W. 29.8 cm, D. 7.4 cm

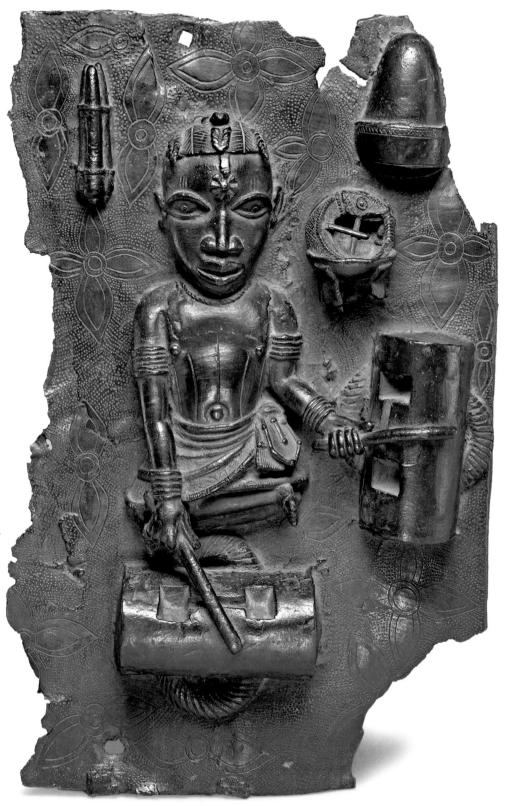

CHAPTER FIVE

WOMEN

As elsewhere in West Africa, female identity in Benin traditionally centred on a woman's valuable childbearing powers, which had to be carefully protected. The most important deity in a woman's life is the aquatic god Olokun, master of fertility, and most women have an often very ornate pot, constantly replenished with river water, which serves as a shrine to the god. Sometimes a mudfish, a favourite creature of the god, will be kept alive in it. Neglect of the pot, or allowing it to dry out, would have dire consequences for a woman's fecundity.

A whole section of the palace compound was given over to the oba's wives, numbered by chroniclers at anywhere between 600 and 4,000. There they were segregated and, until the

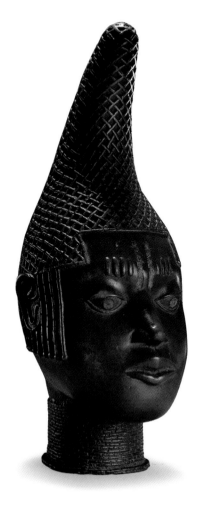

THE FORMAL ELEGANCE of the Queen Mother heads has made them some of the most famous artworks from Benin. After the establishment of her special title by Oba Esigie in the early sixteenth century, the Queen Mother was allocated a separate court in the village of Uselu, just outside Benin City proper. There she maintained a court of women that replicated that of her son in that, for every male titleholder, she had a female one. After her son's accession she was never again allowed to meet him face to face, but in later times the oba's eldest son, the Crown Prince or *edaikon*, lived with her. Her headdress represents a special hairstyle, the 'parrot's beak', which was covered with a network of red coral beads. On their deaths, Queen Mothers were memorialized both on altars at Uselu and in the oba's palace, where this head would have been kept.

FIGURE 68 *Head of a Queen Mother. Cast brass, 16th century. H. 41 cm, W. 15.5 cm, D. 17 cm*

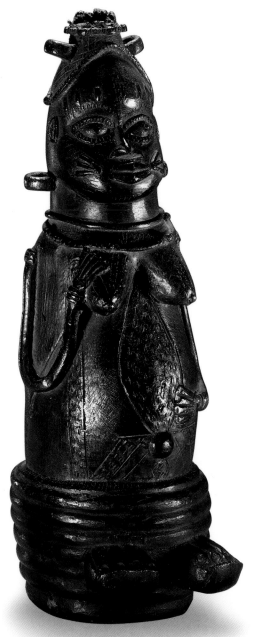

end of the nineteenth century, were tended by eunuchs and by young girls who were themselves future royal wives. It was a grave offence for any male to touch them in even the most fleeting or accidental manner, and they are invisible in the royal art of Benin just as they were in political life.

The most important women in the Benin kingdom were not the obas' wives but rather their mothers (Figs 68 and 74), since status came from a connection with the male through childbirth, not marriage. Oba Esigie (1505–50) is credited with the founding of the title of *iyoba* (Queen Mother) after his mother, Idia, saved his kingship both with the magical powers she possessed and by leading out an army to defeat the enemy. Only around half the Queen Mothers in Benin's history seem to have formally acceded to the title; since the *iyoba* was counted among the Town Chiefs, an oba's ability to install her among them was a measure of his control over them.

Despite being paragons of female virtue, like many mature women in Africa Benin Queen Mothers become ambiguously male as part of their assumption of power. Some African languages refer to the menopause as a process of 'becoming dry' or 'becoming a man'. As it is important that a Queen Mother never bears another child, only after the menopause can she have sexually active male attendants and chiefs to help her in her office, and she is the only royal female that may be touched by men. She wears a version of the oba's regalia and is buried as a male rather than a female. On her death, it is her royal son's duty to cast a brass head for her and set it on her altar, both at her court at Uselu and in his palace. As a powerful person in her own right, she is also likely to have a much richer set of connections with gods and shrines than ordinary women are normally expected to entertain (see Fig. 18), a sign of her larger individual personality.

THE RIGHT HAND of this woman is raised to her breast, the left to her belly, perhaps suggesting that its bulbous form indicates pregnancy. The face bears scarification in the form of cat's whiskers, and there is also scarification of the torso and a herniated belly button. The long spout (now missing) may have extended in the form of the high headdress familiar from the Queen Mother's court. It has been suggested that this was a container for magical medicine. A more likely alternative is that it was a powder flask, the loops being used for suspension, as on other examples. Guns were introduced into Benin by the Portuguese, but the most common arms were long, smooth-bore weapons known as Daneguns of Birmingham manufacture. Muzzle-loading flintlocks, they could be filled with all manner of stones, broken pottery or metallic scrap and were prone to explosion so that soldiers fired them held at arm's length, with eyes closed and face averted.

FIGURE 69 *Vessel in the form of a standing female figure. Cast brass, 18th–19th century.*
H. 29.5 cm, W. 10.4 cm, D. 12.5 cm

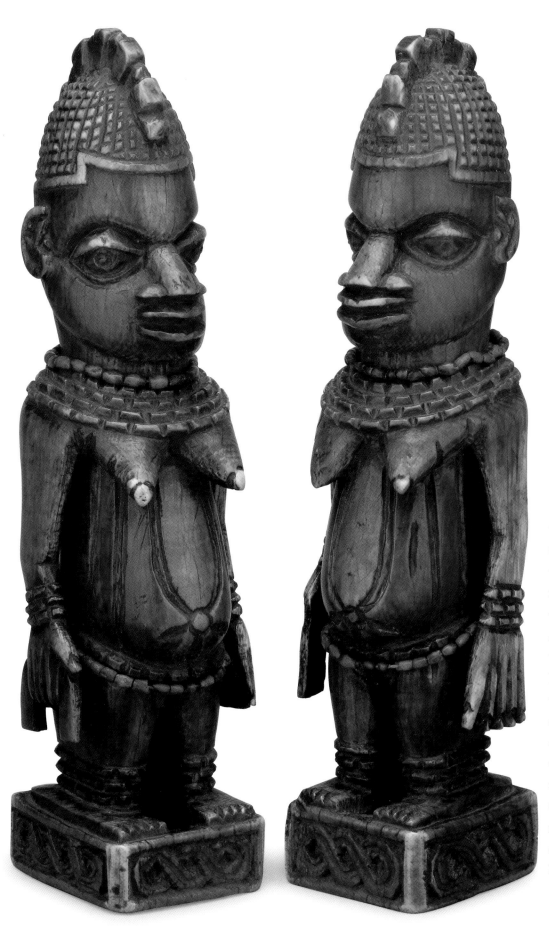

THESE FEMALE attendants from the Queen Mother's court wear the high-woven hairstyle that distinguishes their role, together with wristlets, anklets and the string of beads a woman always wears around her waist. Their torsos are cut with the traditional bodily scarification of Benin women. Young girls were given to the oba before sexual maturity, and his control of them was an important element of royal patronage, allowing him to reward chiefs and supporters or take them as his own wives. These figures would have stood on a Queen Mother's altar.

FIGURE 70 *Pair of female figures. Ivory, 19th century. H. 23.5 cm, W. 6.6 cm, D. 7.2 cm; H. 23.6 cm, W. 6.5 cm, D. 6.5 cm*

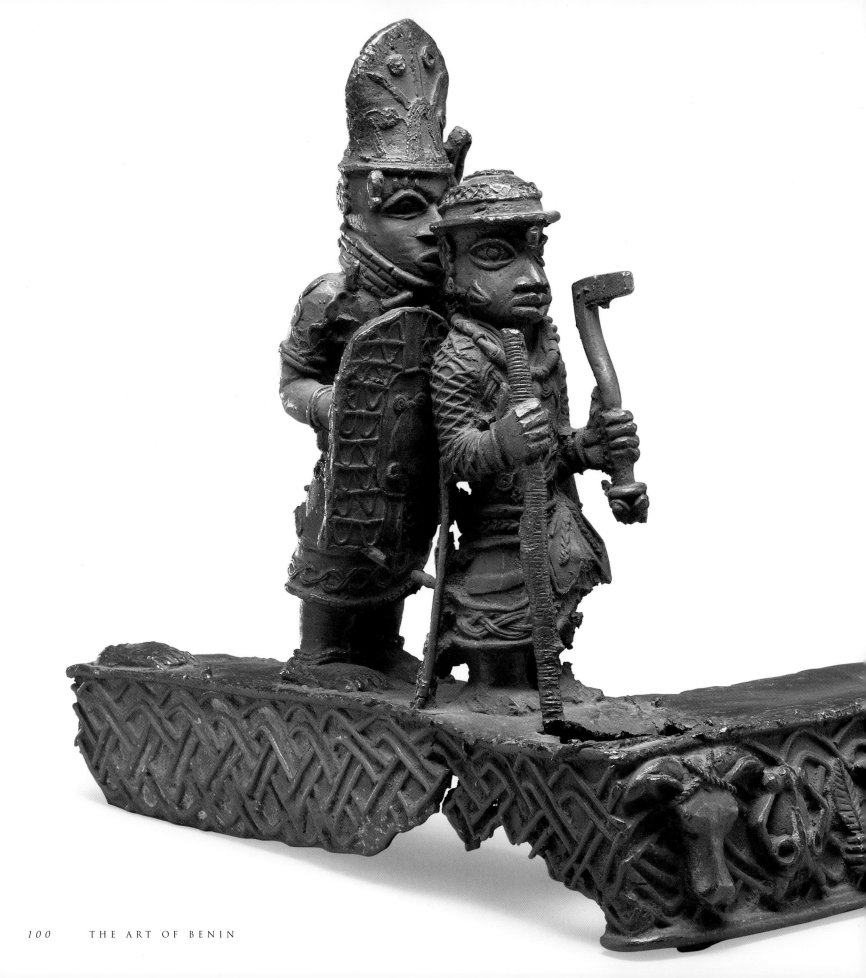

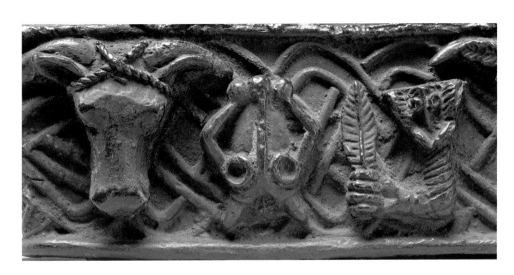

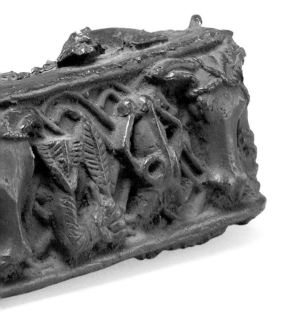

THIS FRAGMENT FROM a large rectangular casting shows a group of figures including a crossbearer like that in Fig. 65. Other complete examples have survived, showing that the main figure of a Queen Mother stood at the centre rear, a female figure behind the two surviving, and an identical group of three on the other side. Many Benin castings are incomplete, and seem from early photographs to have been that way *in situ*. Sometimes the casting process was unsuccessful so that holes were left where the metal did not run. In the palace they seem to have been subject to rough handling, possibly while being polished. Moreover, weak points in a casting often would be reinforced with iron rods, which rusted and expanded in the damp atmosphere of Benin, often shattering the outer layer of brass. The detail above shows a number of standard Benin motifs: a sacrificial cow, a leopard skull and a stylized elephant head gripping a leaf.

FIGURE 71 *Altarpiece. Cast brass, 18th century. H. 27 cm, W. 31.5 cm, D. 29.5 cm*

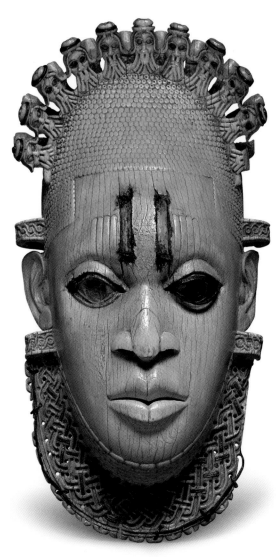

THIS IVORY pectoral mask was found in 1897, together with three others, in a large chest in the oba's bedchamber. The double hoops on either side are for the attachment of a suspension cord so that it may be worn on the breast, in the manner of a similar brass work sent to the tributary ruler of the Igala kingdom. A comparable ivory mask is worn by the oba at the waist during the Igue festival. The headdress is composed of miniature Portuguese heads. Inlaid iron strips marking facial scarification of the forehead have corroded and been lost, but inlay of copper wire has survived. The mask is associated in popular tradition with Benin's most famous Queen Mother, Idia, the first to be given the title of *iyoba* by her son, Oba Esigie. It was used in 1977 as a symbol of FESTAC, the World Festival of Black Arts and Culture, and so became a worldwide cultural icon.

FIGURE 72 *Pectoral mask. Ivory, copper and iron, 16th century. H. 22.5 cm, W. 12.5 cm, D. 8 cm*

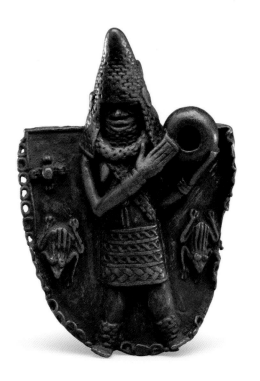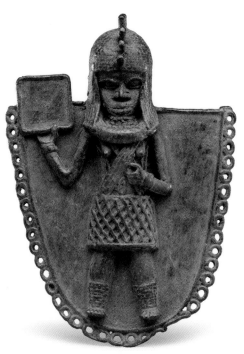

IMAGES OF CHIEFS and obas show ornaments of this general shape hanging from their belts, often bearing images of Portuguese or animals and often in threes. The central figure on each wears a thick rolled necklet of coral beads, similar to that found on a small group of memorial heads of the obas. One holds up a calabash, or water container, the other a flat board, which may be a mirror;

Western mirrors were highly valued and a staple of trade. The latter figure also appears on complex altarpieces. It has been speculated that these ornaments may show acts of divination or amuletic protection, but the figures have not been reliably identified.

FIGURE 73 *Two plaques to be worn on the belt. Cast brass, 18th century. H. 13.5 cm, W. 10 cm; H. 13.2 cm, W. 7.4 cm*

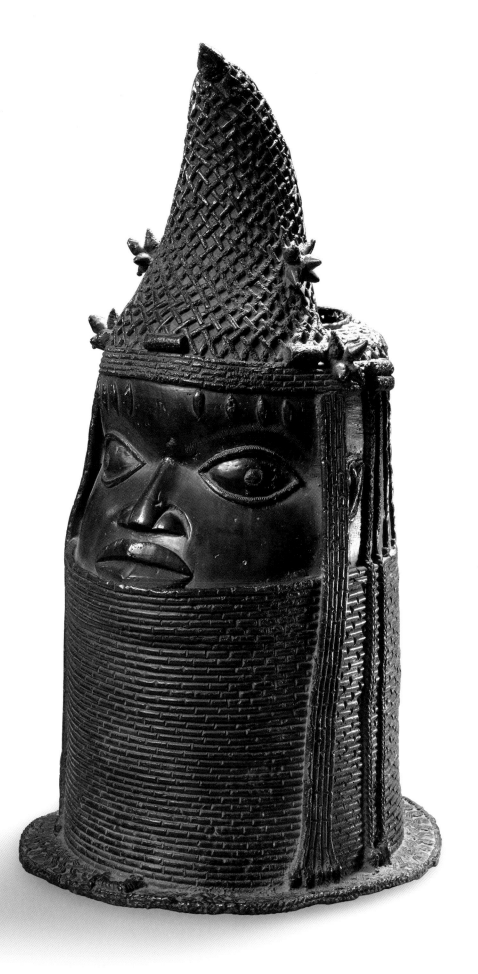

THE QUEEN MOTHER, or *iyoba*, was the only female to hold high office in the Edo kingdom. She is shown here in elaborate bead regalia matching that of the oba. This includes a high collar, headband and hairnet of coral beads and clusters of coral and agate attached to the head. The head stands on a flanged base with ropework pattern and would have carried a large carved elephant's tusk resting on a double-ended stake driven through the crown of the head. The general impression is one of stiffness and monumentality, which contrasts with the sensuous earlier heads such as Fig. 68. The hair is teased up into the 'parrot's beak' hairdo characteristic of royal women.

FIGURE 74 *Head of a Queen Mother. Cast brass, late 18th century. H. 22.6 cm, W. 26.7 cm, D. 29.9 cm*

THIS IDIOPHONE would have been beaten with a striker at the Ugie Oro festival, recalling the slaying of the bird of prophecy by Oba Esigie and his subsequent triumph over his enemies (Fig. 60). For some high notables, *uzama* kingmakers, the cast brass bird beaten on this occasion is replaced by examples in carved ivory. This one shows a Queen Mother beating the ivory gong used by the oba to drive evil spirits from the town. While the carving is finely worked, the facial features and costume are much abraided by use, but combine the normal elements of coral bead regalia.

FIGURE 75 *Carved staff. Ivory, 18th century. H. 32 cm, W. 6.3 cm, D. 5.5 cm*

CHAPTER SIX

ANIMALS

Edo ritual stresses boundaries and the affirmation of them: the line dividing the villages from the city, the town from the palace, the land from the sea. But just as the same objects may be made in different materials, so administrative structures endlessly repeat themselves in different locales. The court of the oba parallels that of Olokun; the court of the Queen Mother is that of the oba translated into female terms; while the brothers sent out to govern outlying areas developed their own pale echoes of the royal court there. So, paradoxically, this concern with boundaries highlights transgressive elements that cross them and, in Benin thought, these have always been attributed with special power. So animals such as crocodiles, frogs and mudfish, at home in and out of the water, snakes

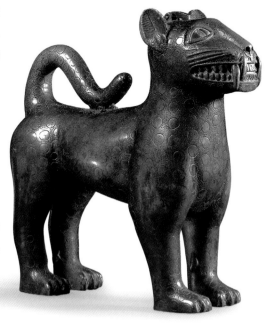

WATER VESSELS of this form seem to have been cast in pairs. A hinged cap between the ears allows water to be poured in while the curved tail provides a handle. Water exits via the nostrils. As in much African sculpture, the head is incommensurately large. The texture and pattern of the fur are conveyed by a mixture of dots and circles, the size of the motifs reducing on the head and tail. This is one of the great classic works of Benin art, with its solid but subtle modelling and curvaceous musculature. However, the overall design so closely resembles that of European aquamaniles of the fourteenth and fifteenth centuries – principally depicting lions and horsemen – that outside influence cannot be excluded. Water from such vessels is nowadays used to wash the oba's hands before making sacrificial offerings. Brass castings of leopard skulls were also part of altar furniture.

FIGURE 76 *Aquamanile (water jug) in the form of a leopard. Cast brass, 1550–1650. L. 30.5 cm*

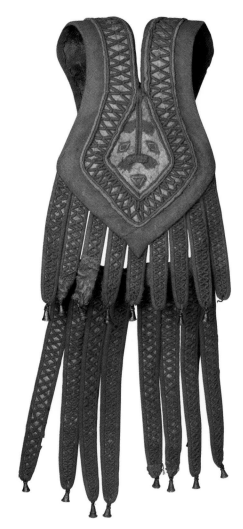

that nest underground but climb trees, birds that fly at night or that fish underwater are all candidates for symbolic thought. Pythons are held to be beautiful and sent to warn humans by Olokun; crocodiles are more likely simply to execute them on the god's orders. Vulturine fish eagles provide the feathers that mark out a chief, being worn in his hair and represented on his memorial heads.

Some creatures have qualities that make them emblems of leadership. Thus leopards are both beautiful and shedders of human blood, they hunt alone and at night. The 'leopard of the bush' corresponds to the oba, whose praise name is the 'leopard of the home', so that any man killing a leopard must come to the oba and swear seven times that he slew only that of the bush and not that of the home. The oba, on the other hand, has leopard hunters to provide sacrificial victims for festivals. The image is then developed, to cover political relations, in the pangolins, scaly ant-eaters, which figure on boxes and in items of dress. Senior chiefs wear a cloth made of flaps of imported red felt known as 'pangolin skin', for the pangolin is the only animal that does not need to fear the leopard: it simply has to roll up in a tight, armoured ball to resist attack. Meanwhile helmets of real pangolin skin were worn by the royal guild of leopard hunters as protection (Fig. 80), a neat marriage of the practical with the symbolically appropriate.

Rams are dominant and aggressive and therefore an apt symbol of chiefship. They are the most appropriate sacrifice on ancestral altars. But, as always in Benin, there is a need to establish a hierarchy. So rams are less impressive than leopards and, indeed, are their prey, while they in turn are more formidable than cockerels, emblems associated with Queen Mothers. It is only appropriate then that elephants, large and dangerous creatures of the bush, are linked to rebellious office-holders, especially the notorious Iyase n'Ode, who opposed Oba Akenzua I and nearly brought down the kingdom in the early eighteenth century.

All this finds its reflection in Benin art. The creatures sacrificed on the altars of high-ranking people and specific gods are naturally those seen as having qualities in common with them, so that animal images on shrines may come to represent both the classes of humans and the sacrificial offerings made by them. The leopard is both the oba and the wild beast killed by the oba. The ram is both the chief and the animal sacrificed by him.

The same is true of the dark creatures that operate in the world of witchcraft. The *osun ematon* of the anti-witchcraft specialists often swarm with such beasts (Fig. 63). The grey heron is the king of the witches; ordinary witches may be able to transform themselves into owls; and lethal serpents may pass between the various realms with their death-dealing venom. A large figure of the grey heron surmounted the entrance to the oba's apartment, while a serpent zigzagged down from its feet to gape just above the door. Both were public declarations of the occult powers of the man who lived there.

THIS COAT IS cut from imported cloth in the form of a leopard skin, with streamers and bells attached. These surcoats are worn by Benin chiefs, alternating with hippopotamus-hide armour, which would offer much greater protection. Benin was famous for its textiles, made from both local and imported materials. The leopard surcoat is part of a sustained image of the warrior – the shedder of human blood – as a leopard (see Fig. 30).

FIGURE 77 *Surcoat. Felt, leather and brass, 19th century. L. 86 cm, W. 41 cm, D. 12.5 cm*

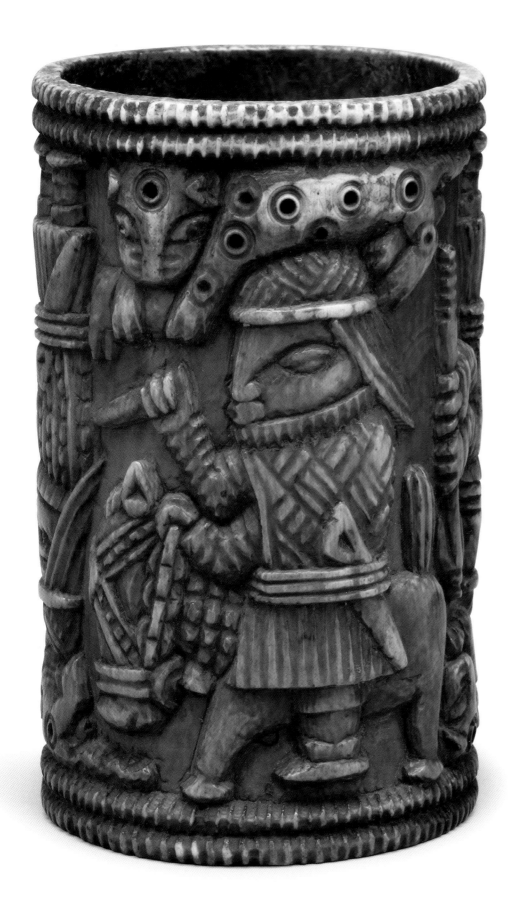

BRACELETS OF this kind were carved in pairs and were probably made for use by chiefs rather than the oba. The bracelet is edged with a double band of vertical incisions and bears figures carved in high relief. That shown is a Portuguese on horseback, executed in profile; the same figure is repeated upside down on either side so that it can be seen by both wearer and viewer. A leopard crouches on a branch above him and prepares to spring, its spots shown as drilled holes. This is a much-used motif in Benin ivorywork as a statement of the power of the king over his rival Olokun.

FIGURE 78 *Carved bracelet. Ivory, 19th century. H. 12.5 cm, diam. 9 cm*

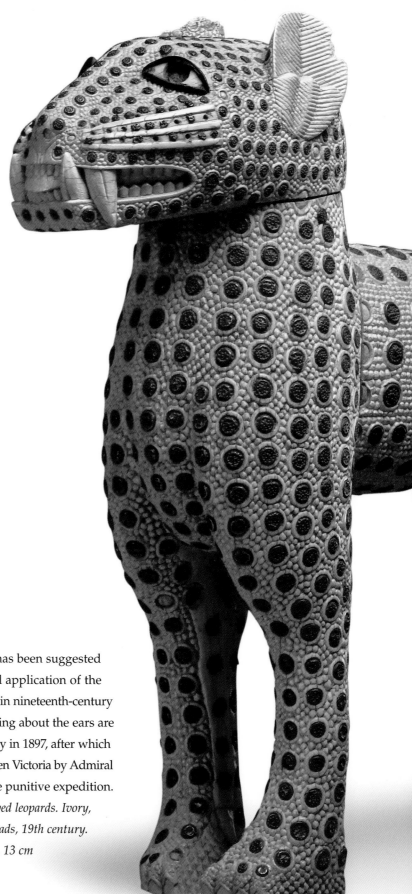

THIS UNIQUE PAIR is not just a representation of leopards in ivory but also of brass leopard aquamaniles in a different medium. Carved from six pieces of ivory pegged together, they could never have held water, but the cap between the ears – through which water might have been poured into brass versions – has been carefully represented. The spots of the leopards are shown with copper discs etched with dots. It has been suggested that these are a novel application of the percussion caps used in nineteenth-century rifles. Signs of scorching about the ears are from the fire in the city in 1897, after which they were sent to Queen Victoria by Admiral Rawson, leader of the punitive expedition.

FIGURE 79 *Pair of carved leopards. Ivory, with strings of coral beads, 19th century. H. 47 cm, L. 88 cm, D. 13 cm*

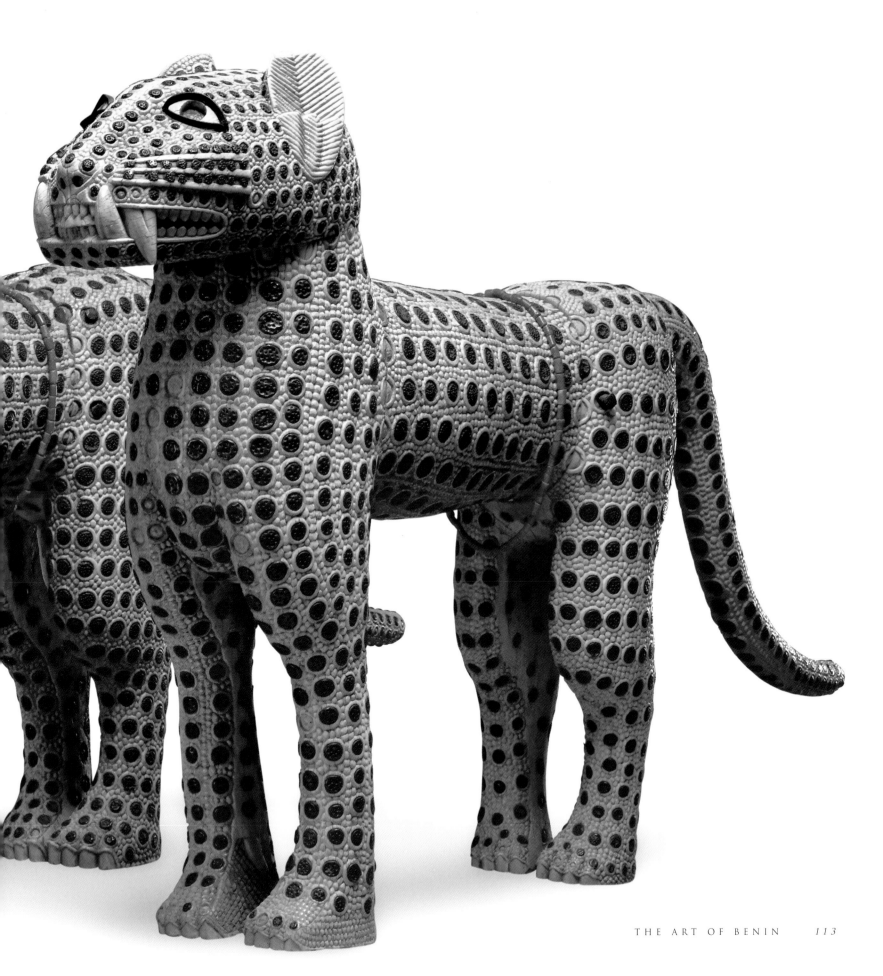

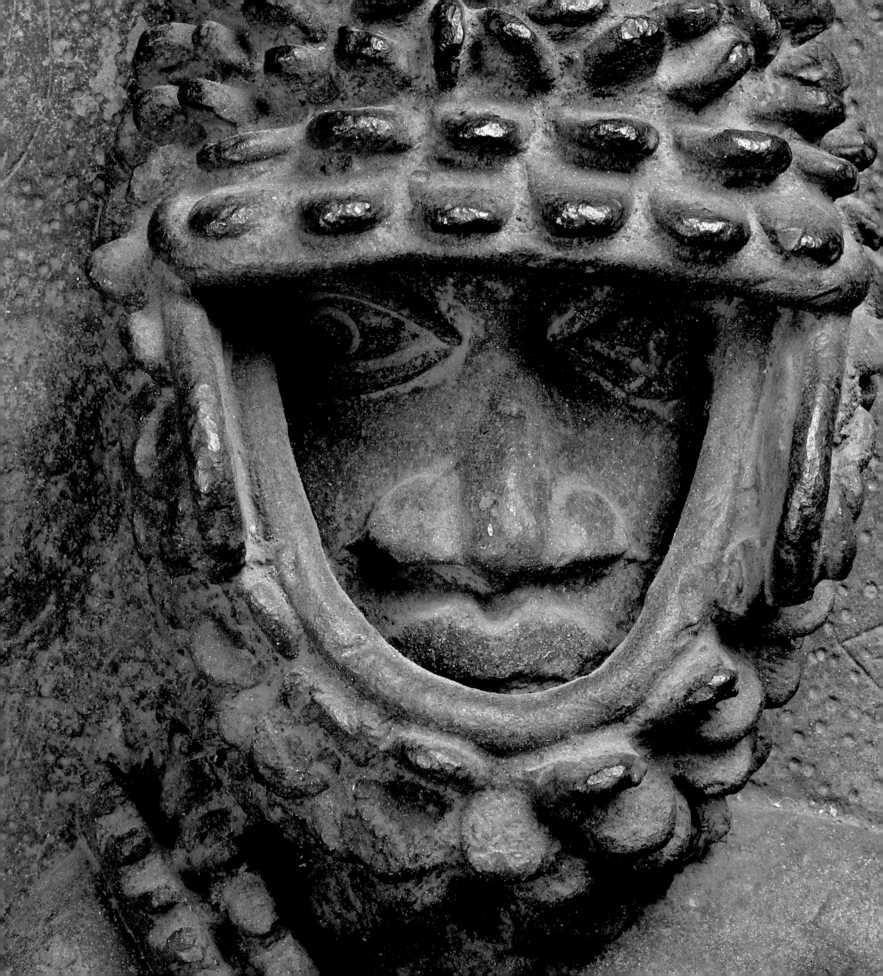

THE OBA RETAINED a special group of leopard hunters, who tracked down females with cubs that could be taken, raised and tamed within the palace to make suitable victims for offering to the oba's head. The hunters are armed with bows and arrows and armoured with helmets of pangolin skin. Trussed leopards are displayed between them.

FIGURE 80 *Plaque showing hunters. Cast brass, 1550–1650. H. 50 cm, W. 36 cm, D. 11 cm*

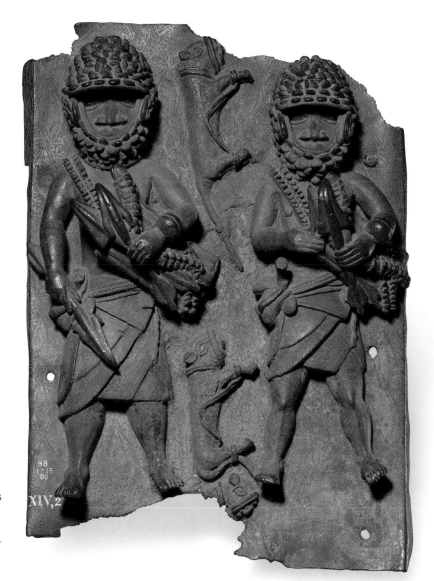

IT HAS BEEN suggested that Benin art distinguishes two species of crocodile, short- and long-snouted, the latter being far more dangerous. However, if this is the case, the symbolic connotations of each are not clear. The head of a crocodile – seen as the 'policeman of the waters' and associated with Olokun – offers a perfect subject for the tension between naturalism and geometric abstraction that characterizes the best works of Benin art.

FIGURE 81 *Plaque showing the head of a crocodile. Cast brass, 1550–1650. H. 45.4 cm, W. 18.4 cm, D. 4 cm*

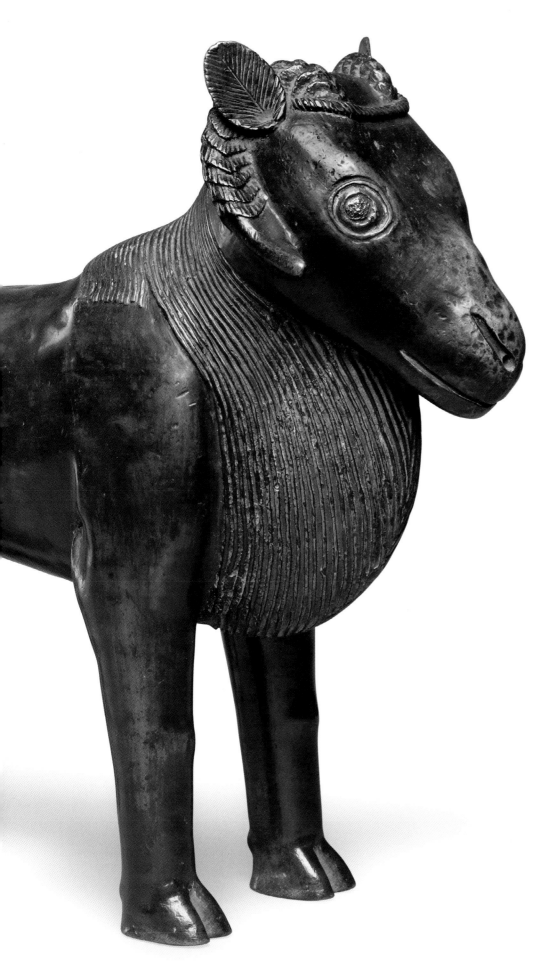

THIS WORK IMPRESSES by its sheer simplicity. Apart from etching in the flow of the long hair around the neck, the artist has resisted all temptation to elaborate the fleece. Ears are depicted like leaves and a simple stretch of rope between the horns shows that the beast is about to be sacrificed. Although rams were often associated with chiefship, they were also sacrificed on royal altars.

FIGURE 82 *Aquamanile in the form of a ram. Cast brass, 16th century. H. 33.9 cm, W. 13 cm, D. 44 cm*

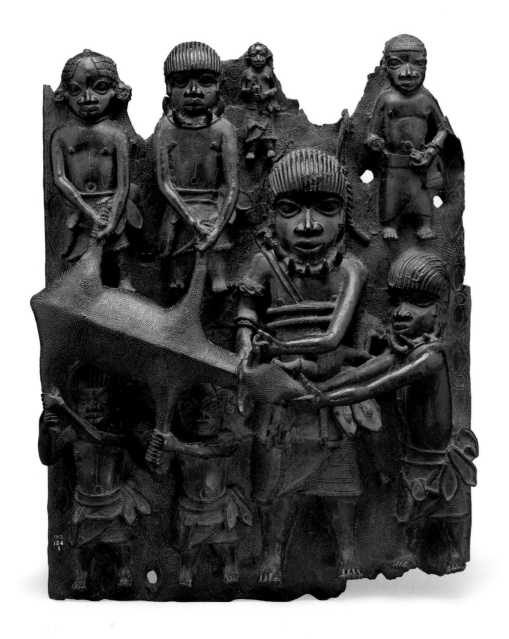

CATTLE WERE ONLY sacrificed in Benin on extremely rare occasions. This plaque probably shows the festival of Igue, held to strengthen the oba's head. It is one of the most complex and accomplished of all the plaques, incorporating eight figures and what is presumably a bullock, raised high off the surface. It is one of a small group of plaques whose relief is so high as to be almost three-dimensional. The beast is held by five of the figures while a sixth performs the sacrifice. The implements in the hands of some of the figures have been lost. This is one of the plaques in which the temptation of the 'photographic illusion' is at its strongest, since the figures are carefully spaced, posed and frozen, looking towards the viewer as if towards a camera.

FIGURE 83 *Plaque showing the sacrifice of a bullock. Cast brass, 1550–1650. H. 51.3 cm, W. 41.5 cm, D. 11.4 cm*

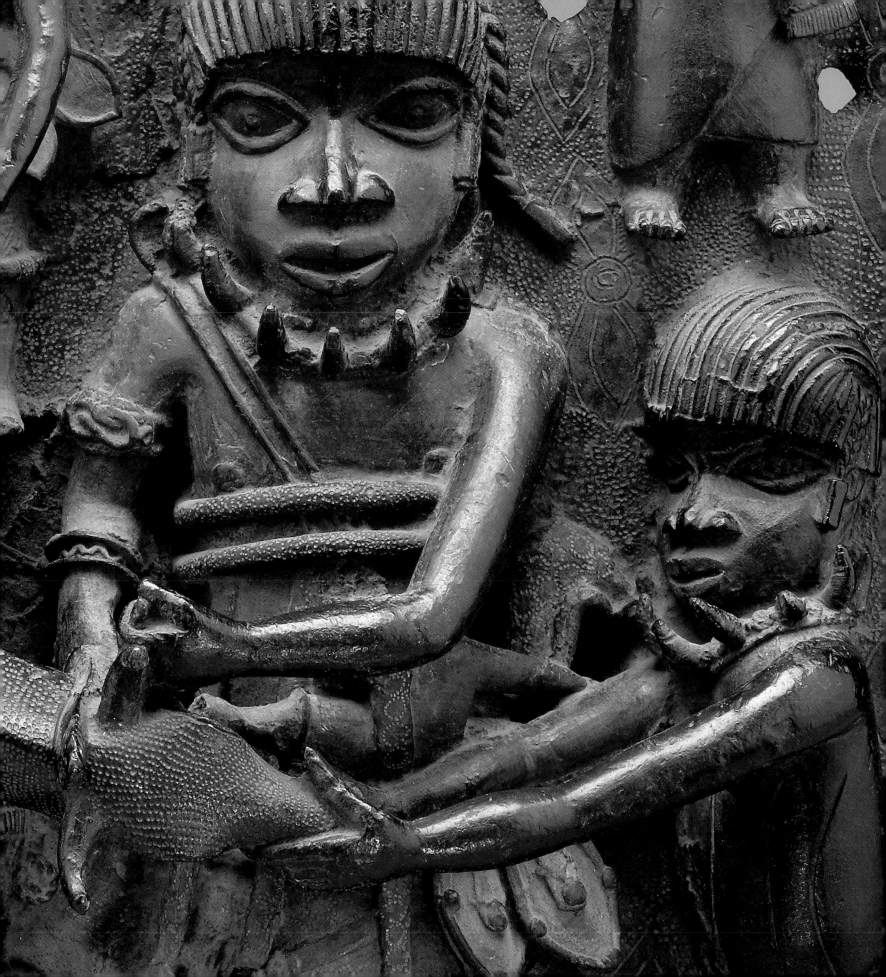

TWO MUDFISH are stylized, flattened and set on a flared pedestal to provide a low, stable support. The eyes are of iron inlay cast into the brass and the barbels (whiskers) have been exaggerated. Delicate surface patterning divides the fish into sections of anatomical significance and conveys a vivid sense of movement unusual in Benin. While many kinds of stool existed in the Benin court, only one other of this form is known.

FIGURE 84 *Stool in the form of two inter-twined mudfish. Cast brass, 1550–1650. H. 12.5 cm, W. 37.1 cm, D. 26 cm*

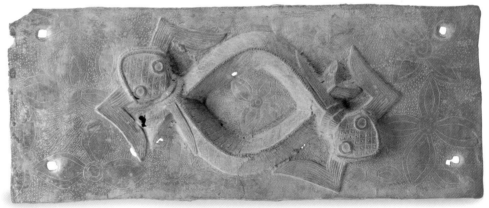

FISH ARE COMMON in Benin art, particularly members of the mudfish family, whose classification in Edo is complex and which are difficult to identify specifically in art. The geometric possibilities of the intertwining of animal forms is a constant Benin concern and the balance here reinforces the mythic liminality of the creatures shown. Mudfish can move between the land and the water, the realm of the oba and that of Olokun. In the dry season they can retreat into the mud and survive for long periods so that, after rainfall, watercourses may suddenly boil with life that has appeared – seemingly – from nowhere. They also produce a powerful electric shock, which makes them a suitable messenger of the god. More than seventy depictions of fish survive in Benin art, quite disproportionate to their dietary importance.

FIGURE 85 *Plaque showing two intertwined mudfish, Cast brass. 1550–1650. L. 46.8 cm, H. 18.6 cm, D. 3.4 cm*

THE SPLENDOUR OF this casting derives not just from the bold assertiveness of the pose and its massive size, but from the extraordinary rendering of the plumage, which shows both the direction and the texture of the feathers while using recurrent abstract markings in a way wholly typical of Benin art. Hens and cockerels are both suitable animals for sacrifice in Benin, but only cockerels are deemed appropriate to symbolize domineering prominent females. The oba's chief wife, the *eson*, has the praise-name 'the cock who crows the loudest', while the male attributes of a cockerel with its 'harem' of hens are appropriate for the Queen Mother and her female court. About two dozen castings of this kind are known from the classical corpus of Benin royal art.

FIGURE 86 *Statue in the form of a cockerel standing on a square block with guilloche pattern. Cast brass, 18th century. H. 41 cm*

COMPARISON OF THIS work with Fig. 86 shows the differences between the more naturalistic brass pieces and those carved in wood. The chicken is here translated with great verve into a combination of pure geometric forms and portrayed as a large bulbous sphere, with a pointed spike in the middle of its back, on top of a rounded pedestal. Sinuous lines swirl around the neck and deep grooves score the belly. The wings are marked by incised diamonds. Chickens of this form were probably placed on the altars of Queen Mothers, and the mothers of the male heads of large families, since female status was always dependent on connection with a powerful male.

FIGURE 87 *Chicken. Wood, 19th century. H. 29 cm, W. 17 cm, D. 20 cm*

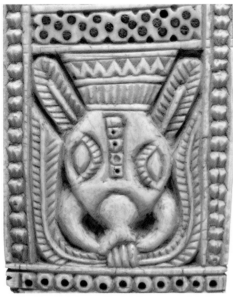

THE YORUBA TOWN of Owo, some seventy miles north of Benin City, claims divine descent for its rulers from Ife, as is usual for Yoruba polities. Some Benin sources allege that it was conquered under Oba Ewuare in the mid-fifteenth century. Although this is denied in Owo, the persistence of Benin-derived titles and Benin-style regalia there makes it likely, and later traditions suggest continuing strong Benin influence on the Yoruba polity even in later times. This box is one of a number of pieces found in Benin in 1897 but stylistically clearly of Owo origin.

The working of the faces with parallel lips and inlaid pupils, cross-hatched hair, the obsessive use of piercing and openwork, along with certain animal motifs, all confirm the link. The use of zigzag designs, coconut-shell inlay and the extreme elongation of the leaves are further clear diagnostics of Owo work. Owo was an important source of ivory and the detail shows a very Owo rendition of the motif of an elephant head grasping leaves in its trunk, which was common in Benin.

FIGURE 88 *Carved lidded box. Owo. Ivory, 18th century. H. 4.7 cm, L. 9.5 cm, D. 6.2 cm*

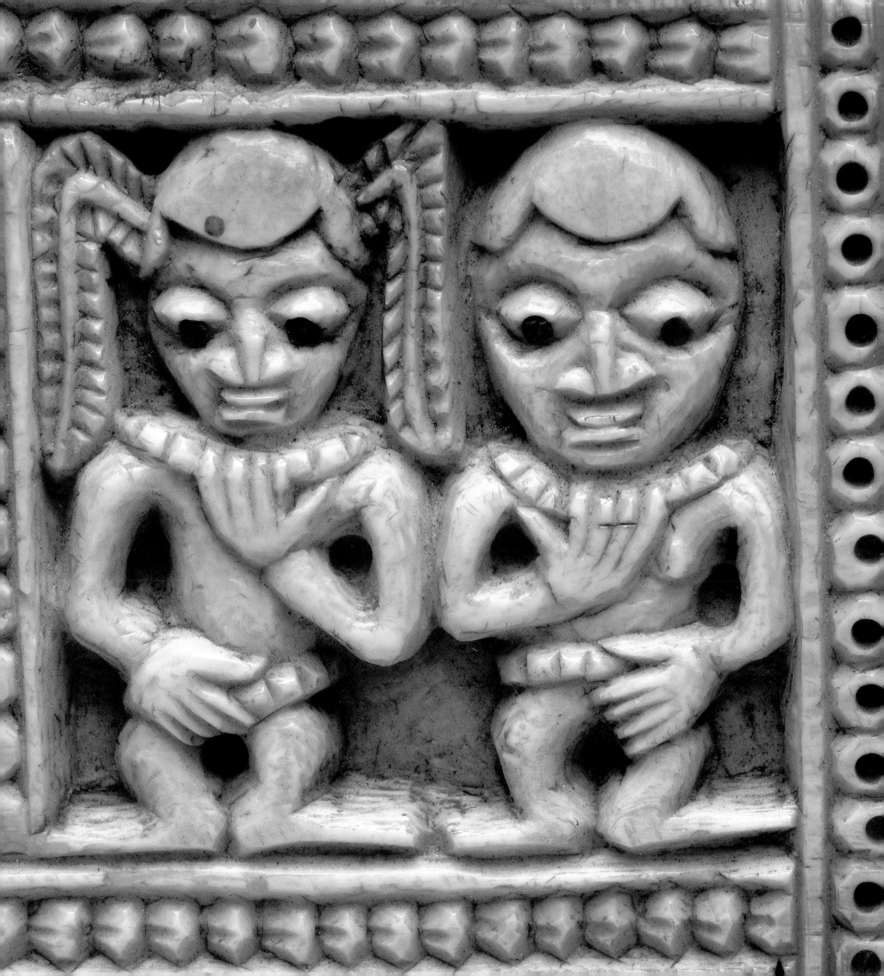

THE *UKHURHE* OR rattle staff is the most important element of an altar across all social classes. Unlike the artistically more striking metal and ivory figures and heads, it is indispensable, whereas they are largely optional, ornamental elaborations. It is struck on the ground to attract the attention of spirits when an offering is made, calling for blessings or curses.

Differences of rank may be marked in the materials from which the staffs are made. While almost all are made of wood, a very few royal staffs are made of brass or ivory. At the tip is a hollow segment containing a loose cylinder that is free to rattle. They are made in the form of a segmented, bamboo-like plant called *ukhurhe-oho*, which grows wild in the forest and is notable for producing small branches that break off after reaching a certain length, therefore symbolizing the individual within the community and the succession of generations in life. The top of such a staff may be carved in the form of a human head or a human figure, often an oba. Royal staffs frequently depict the ritual gesture of a clenched fist with extended thumb, or any of the 'royal' animals such as leopards, mudfish or snakes. This piece is topped with a small squared elephant clutching a branch in its trunk (see the detail at left).

FIGURE 89, ABOVE AND LEFT Ukhurhe *rattle staff with a finial in the form of an elephant. Ivory, 18th century. L. 66.2 cm, W. 7.3 cm, D. 8.2 cm*

THIS STAFF IS thought to have held medicines in the container at the top and to have been used by the oba to add magical force to his pronouncements. The silver mount is a European addition and the original lid is missing. The staff depicts along its length an extraordinary sequence of animal transformations: the stem becomes a large foot, resting on the back of an elephant, flanked by mudfish which are grasped by a fist that transforms into snakes. The elephant is supported in turn by vultures facing a serpent which coils between brass spirals to transform into a serpent head swallowing a fish.

FIGURE 90, BELOW *Staff. Stained ivory, brass and silver, 18th century. L. 66 cm*

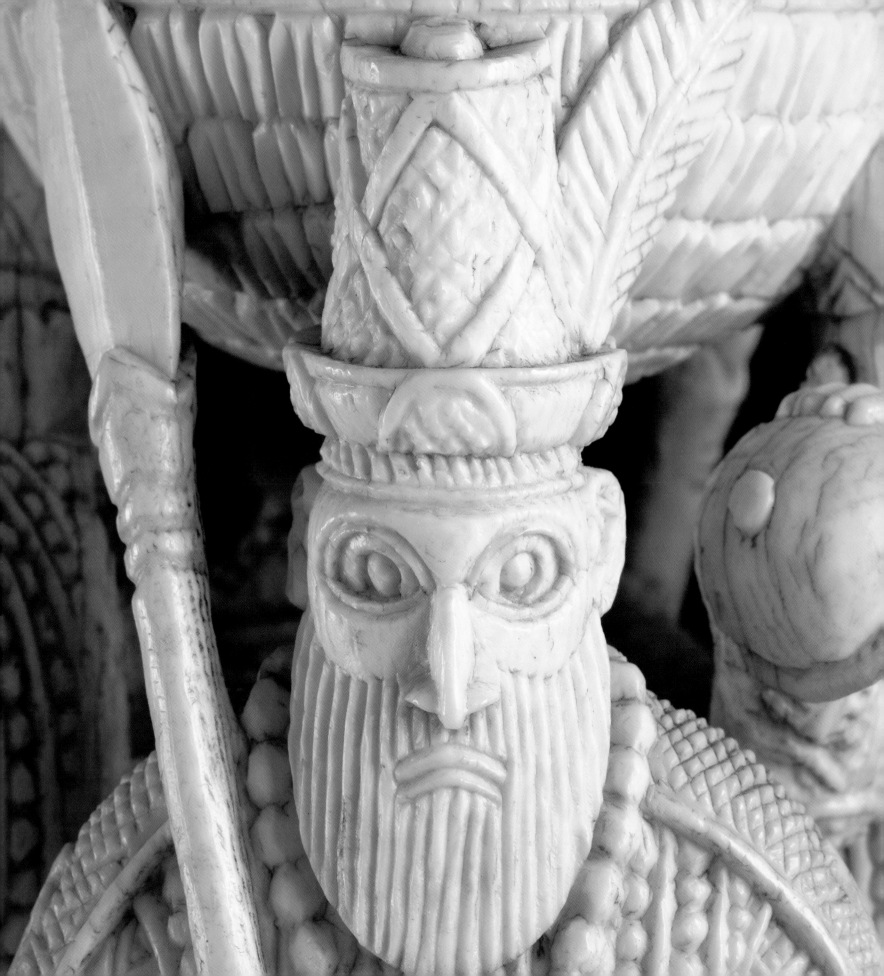

WESTERNERS

FROM THE LATE FIFTEENTH CENTURY ONWARDS, BENIN'S CONTACT WITH EUROPEANS WAS unbroken and – until the very end – friendly, being based on mutually beneficial trade. Officials were exchanged, presents were made, missionaries went out to Benin and, initially, had some success in conversion. Witness to those times are the Afro-Portuguese ivories, luxury items such as salt cellars, horns, spoons and dagger handles, made by Africans for the new foreign market. The copious supplies of precious brass and copper that the Europeans brought with them offered an enormous new resource for the arts of Benin, and the artistic explosion that produced the plaques between 1550 and 1650 is unthinkable without them. For hundreds of years Benin art developed in the framework of European contact.

It was images of Westerners that first attracted outside attention to the art of Benin. However, the Portuguese not only offered an artistic opportunity to the kingdom but also challenged its view of the world. Just as the Portuguese sought to incorporate the Edo into the framework of a pre-existing kingdom of Prester John, so the Edo assimilated the Europeans into their idea of an underwater realm in which Olokun dwelt in luxury. European heads, sometimes reduced to mere iconographic squiggles, became a mark of the god Olokun, counterpart of the oba, and at times seem to be little more than a repetitive decorative motif like the other geometric forms that fill in the backgrounds and empty spaces of Benin objects. The placing of Portuguese figures on the roof of the king's apartments illustrates the way they were successfully reduced symbolically to minor elements in a larger Benin scheme of things.

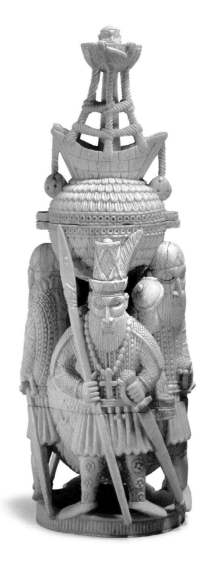

In the early period Benin's primary export was alligator pepper, but this was to prove the first of many disappointments in the Benin trade since it failed to compete with the more desirable south-east Asian varieties. Ivory and textiles were other sought-after goods, and the importance of cloth – widely available in any village – in the second half of the seventeenth century seems to have gravely undermined the oba's ability to control trade. Early on Benin supplied few male slaves for export to African buyers further up the coast and only in the nineteenth century did rubber and palm oil become important commodities. Brass and copper manillas were supplemented by other trade imports such as lead, cowries, coral and European hats, as well as firearms, spirits and iron. From the first Benin treated European goods as essentially raw materials to be turned into objects of interest to the royal court (Fig. 95). The oba constantly struggled with others to maintain control of foreign trade and his ultimate weapon was to simply close it down since it involved luxury goods rather than anything necessary for survival. In the course of the centuries, the Portuguese were displaced by the Dutch, the French and the British. It is not clear that these differences were perceived by the Edo, who continued to represent them as the same long-haired wearers of hose and doublets as in the sixteenth century.

FOLLOWING EARLY contact between Europe and Africa, a number of luxury objects were created specially for Europeans by African craftsmen. This was the earliest tourist art. In a number of places, from Sierra Leone to the Congo, goods such as spoons, forks, horns, chalices and salt cellars were made in a compromise between African and Western styles. In Lisbon a work such as this might fetch the same price as a good linen shirt. Some of the sources of the images used in these carvings have been traced to European prints and coins. The spheres at the ends of the European ship are probably the flat discs of drift anchors, as interpreted by someone working from a two-dimensional image, who has never seen them in place. Since wooden joinery was largely unknown in Benin, the planks of the vessel have been reproduced after the fashion of the wooden shingles on the royal palace. The figure in the crow's nest holds a megaphone, not a telescope (not invented until the seventeenth century). The main figures wear *brigandines*, jackets lined with metal plates attached with rivets, and bear crosses and keys. The central figure seems to be copied from an official portrait of Afonso de Albuquerque (1453–1515), governor of the Indies. Some fifteen examples of Benin salt cellars have survived and, even within such a small group, a number are virtually identical. As elsewhere in Benin art, the endless possibilities have been reduced to a few standard forms that are then constantly repeated.

FIGURE 91, PREVIOUS PAGES AND RIGHT *Afro-Portuguese salt cellar, carved in three sections. Ivory, 15th–16th century. H. 29.2 cm, W. 11 cm*

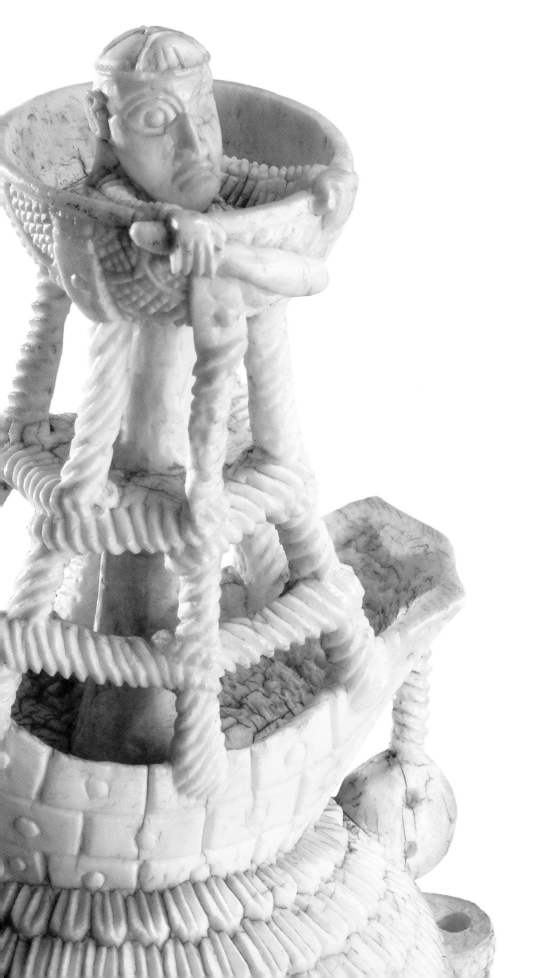

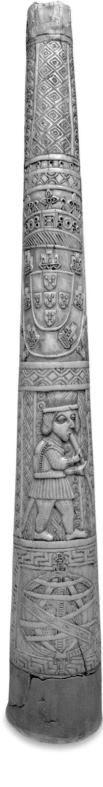

THE *INGBESAMWAN* guild of ivory carvers was unusual in that its members were occasionally allowed to work for outsiders, being much less subject to royal control than the brass casters. This piece was made by African carvers to appeal to European tastes. The horn probably ended in a mouthpiece gripped in the jaws of a beast. Significantly, unlike the horns made for domestic purposes (Fig. 42), the aperture is at the end, not on the convex edge. Many of the geometric motifs are typically Edo, as is the division of the tusk into bands of images arranged vertically. The three main panels show the arms of Portugal (House of Aviz, r. 1385–1580), a European horn player and an armillary sphere, all clearly derived from Western sources.

FIGURE 92, LEFT AND RIGHT *Carved Afro-Portuguese horn. Ivory, 16th century. L. 39.4 cm, W. 6.5 cm*

THIS DELIGHTFUL carving of a European with his hand to his sword shows a mixture of careful observation and stylization. The pose is a common one in paintings of the period. Dress and arms are reproduced with delicate accuracy but the feet are bare. It is interesting to note that Europeans commissioned images of themselves rather than any of the novelties they encountered in Africa. On the other hand African interest within the Afro-Portuguese carvings always focuses on features that challenge previous experience, so particular attention is devoted to the prominence of noses and ears, luxuriance of beard and straightness of hair. This piece would have been used as a serving spoon on ceremonial occasions.

FIGURE 93, RIGHT *Carved Afro-Portuguese spoon. Ivory, 16th century. L. 19.5 cm*

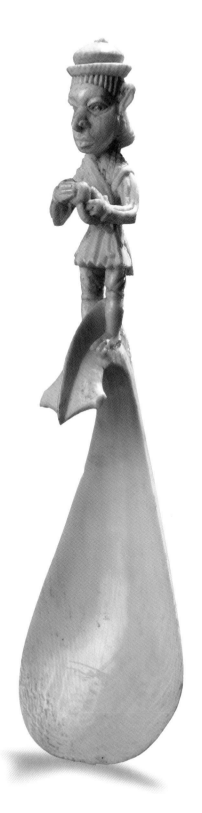

THIS PIECE HAS prompted some debate. Ivory bracelets with metal inlay are not common in Benin, but not unknown. Gilded objects are much rarer since the technique of mercury gilding seems not to have been practised by the Edo, though we know that a Dutch gilder was operating further up the coast in the eighteenth century. It seems likely that the gilded elements were imported from the West, perhaps even attached to another object, and a bracelet carved to receive them, in which case the Portuguese heads are totally appropriate. The shapes of the inlays echo other Benin designs, for example a motif found on Benin shields (see Fig. 30).

FIGURE 94 *Bracelet. Ivory, copper and gilded metal, ?18th century. L. 12.9 cm, diam. 10 cm*

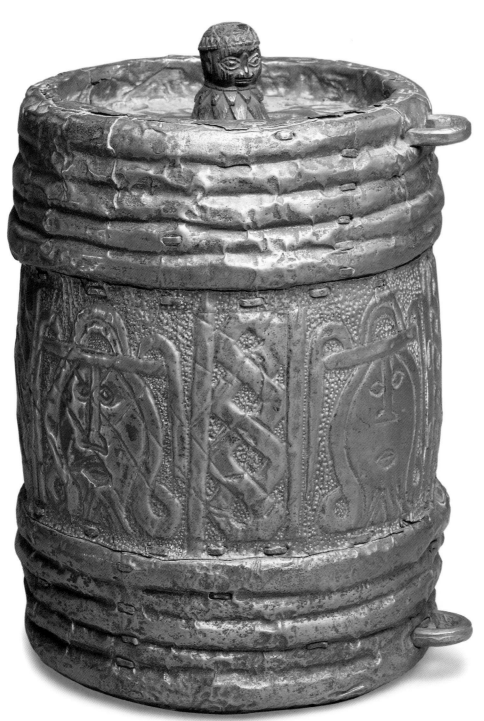

EVEN THE CONTAINERS of European goods could be of interest to the people of Benin. This keg probably held gunpowder and has been converted into a vessel for use in the court by applying repoussé brass sheeting. An appropriate decoration is a schematic European head. The design has been completed with a matching plug in the form of a human torso.

FIGURE 95 *Keg. European. Wood covered with brass sheeting, 19th century. H. 28.2 cm, diam. 34 cm*

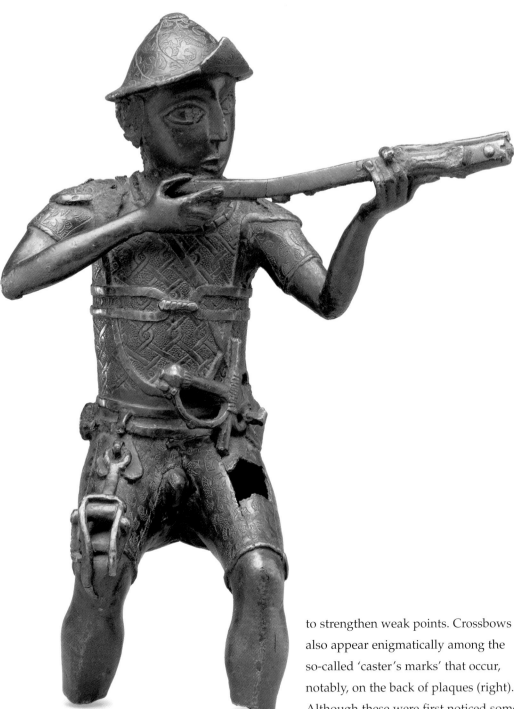

THIS FIGURE is a Portuguese soldier firing a crossbow. Crossbows were used by the Edo and may well have come from Europe. The device on his right hip is for spanning the bow. The casting has been shattered by the corrosion and expansion of iron rods set inside the legs and ankles to strengthen weak points. Crossbows also appear enigmatically among the so-called 'caster's marks' that occur, notably, on the back of plaques (right). Although these were first noticed some hundred years ago by the Austrian scholar Felix von Luschan, they have never been exhaustively studied.

FIGURE 96, LEFT *Figure of a Portuguese soldier. Cast brass, 16th century. H. 35 cm;* RIGHT *Detail of caster's mark in the form of a crossbow, from the back of a cast brass plaque.*

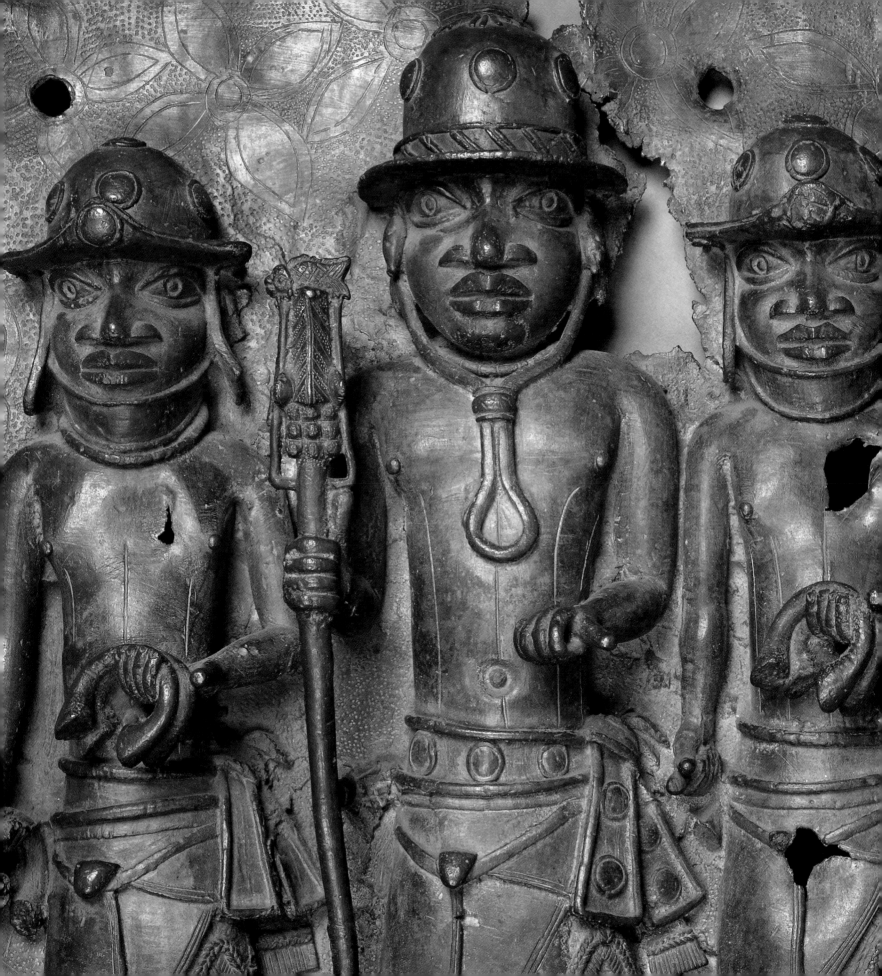

THIS PLAQUE shows the oba's officials responsible for controlling foreign trade. Probably all three figures were originally intended to be holding manillas. This is a rare element in Benin art where, normally, manilla bracelets are exclusively borne by Europeans. The central figure, enlarged to show his importance, carries a staff that ends with a crocodile grasping a mudfish in its jaw. The crocodile is 'the policeman of the waters' in Benin thought and associated, like Europeans, with the god Olokun. The same motif occurs on the handles of Afro-Portuguese spoons made for foreign sale.

FIGURE 97, OPPOSITE *Plaque showing three figures. Cast brass, 1550–1650. H. 51.5 cm, W. 36.8 cm, D. 11.4 cm*

THIS IS A MOST unusual plaque. The European head is of standard form, showing the usual Benin concentration on the sculpted beards and long, straight hair of the European visitors and their variety of hats. Instead of the usual Benin insistence on containing the whole object within the frame, the caster has deliberately chosen to represent two half manilla bracelets at top and bottom instead of a single complete object. Benin artists prefer to deform or even dismember an object completely rather than do this. It seems unlikely that this is a rare plaque that was cast in two vertical sections (just as plaques are known to have been cast occasionally over two horizontal sections). Since plaques were cast in matching pairs, perhaps this is a bold innovation of the artist demanding continuity of the eye across two pillars.

FIGURE 98, ABOVE *Plaque showing a European head. Cast brass, 1550–1650. H. 47.7 cm, W. 14.9 cm, D. 2.8 cm*

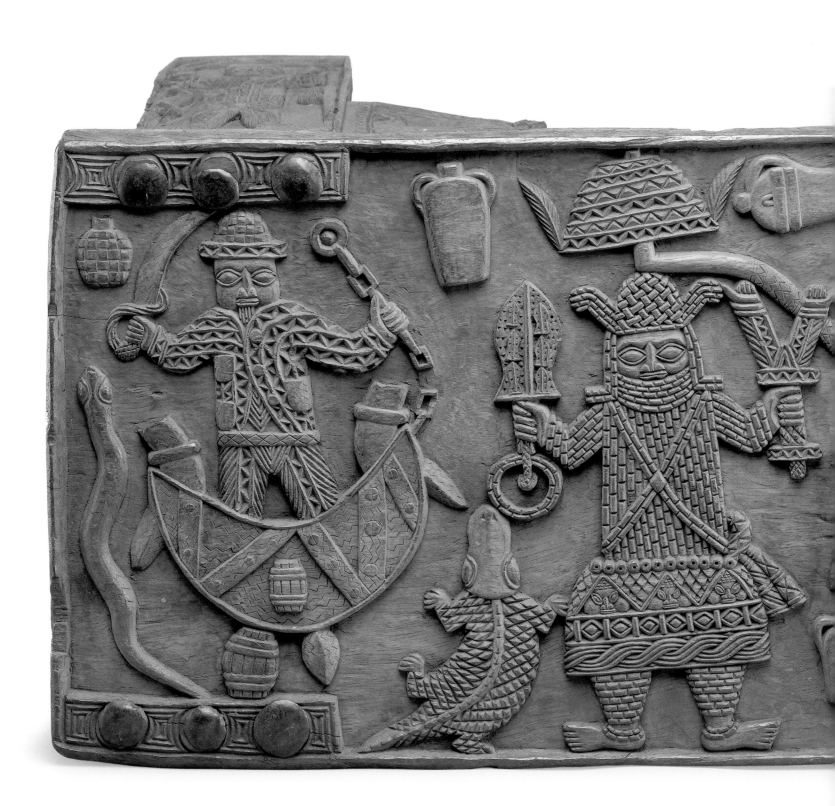

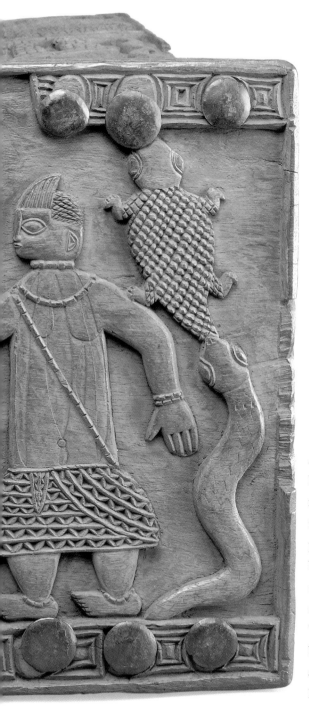

A DISTINCTION has been made in Benin wood carving between works by members of the wood carvers' guild and those of 'amateurs' within the palace, principally court pages. This stool is by the latter and shows a more lively arrangement of images than the more constrained designs of the guild workers. The lid shows an oba sandwiched between a European shipboard trader and a retainer bearing an umbrella. Images of trade are scattered among the more conventional images of royal power. This is clearly a less traditional design than some of the other kinds of stool found in Benin, but is considered one of the oldest. Jointed wood is a sign of Western influence, as is mirror inlay. The forest kingdom normally had trees of sufficient size to carve any required object from a single trunk.

FIGURE 99 *Carved* agba *stool. Wood with mirror inlay, 19th century. H. 39.5 cm, W. 62.5 cm, D. 33 cm*

FURTHER READING

E. Bassani and W. Fagg, *Africa and the Renaissance: Art in Ivory*, New York, 1988

P. Ben-Amos, *The Art of Benin*, London, 1980

P. Ben-Amos, *Art, Innovation, and Politics in Eighteenth-Century Benin*, Bloomington and Indianapolis, 1999

R. Bradbury, *Benin Studies*, New York and Ibadan, 1973

O. Dapper, *Description de l'Afrique*, Dutch edn, Amsterdam, 1668

W. Fagg, *Afro-Portuguese Ivories*, London, 1959

W. Fagg, *Nigerian Images*, London, 1963

W. Fagg, *Divine Kingship in Africa*, London, 1978

D. van Nyendael, *A Description of Rio Formosa or the River of Benin* (1705), London, 1967

J. Picton, 'Edo Art, Dynastic Myth and Intellectual Aporia', *African Arts* 30 (4), pp. 18–25 and 92–3

B. Plankensteiner (ed.), *Benin Kings and Rituals*, Ghent, 2007.

C.H. Read and O.M. Dalton, *Antiquities from the City Of Benin and from Other Parts of West Africa at the British Museum*, London, 1899

H. Roth, *Great Benin: Its Customs, Arts and Horrors*, Halifax, 1903

A. Ryder, *Benin and the Europeans*, London, 1969

ILLUSTRATIONS

Except where otherwise stated, photographs are
© The Trustees of the British Museum, courtesy of the
Departments of Africa, Oceania and the Americas and
of Photography and Imaging

ILLUSTRATIONS